THE ART STUDENTS LEAGUE

Selections from the Permanent Collection

by Ronald G. Pisano

Biographical essays by Beverly Rood

Exhibition organized by the Heckscher Museum Huntington, New York

Circulated by Gallery Association of New York State

The Art Students League
Selections from the Permanent Collection
has been made possible by public funds from the
New York State Council on the Arts, and by grants
from the John Sloan Memorial Foundation, Inc.,
and the Allen Tucker Foundation.

About the Gallery Association

The Gallery Association of New York State is a nonprofit cooperative that provides traveling exhibitions,
circulating film programs, art transport, fine arts insurance, and exhibit design services to more than 260 museums
and other exhibiting institutions throughout New York State and the surrounding region. For more information,
write to Gallery Association, Box 345, Hamilton, NY 13346-0345, or call 315 824-2510.

The Gallery Association's programs are made possible by its members; by public funds from the New York State
Council on the Arts, New York Council for the Humanities, and National Endowments for the Arts and Humanities;
and by contributions from Central New York Community Foundation, Robert Sterling Clark Foundation, The
Dow Chemical Company, IBM Corporation, The J.M. Kaplan Fund, Leading Edge Hardware Products, Inc.,
Metropolitan Life Insurance Co., Mobil Foundation, Inc., New York State Newspapers Foundation, New York
Telephone, The New York Times Company Foundation, J.C. Penney Company, Inc., Philip Morris, Inc., and
The John Ben Snow Memorial Trust.

ISBN 0-934483-09-4

Acknowledgments

I have vivid childhood memories of walks up West 57th Street, seeing the odd displays at Henri Bendel's and the huge, brilliant samovar in the window of the Russian Tea Room, and hoping I might catch a glimpse of someone famous entering or leaving Carnegie Hall. But on the other side of the street, opposite Lee's Art Supply, stands a building which held even more allure to me as a child—the Art Students League of New York. As the daughter of a former League student (my mother studied there during the early 1950s), I was told many stories about people at the League and the very special atmosphere that created a strong union between teacher and student.

This exhibition is testimony that, indeed, the Art Students League is a unique institution where teaching excellence and a spirit of camaraderie throughout its long history have fostered the visual arts in important ways. The Gallery Association of New York State is pleased to have had a part in bringing the work of the Art Students League to the attention of a larger audience by organizing the tour of *The Art Students League: Selections from the Permanent Collection.*

On behalf of the Gallery Association, I would like to express my sincere thanks to the Art Students League of New York for allowing us to share this collection with several museums during the tour. It certainly would not have been possible without the tremendous efforts made by the League. (At the expense of the League, nearly every piece was given attention by a professional conservator, several acquired new frames, and photographs documented all works.)

Special thanks are extended to the following: Rosina Florio, Director of the Art Students League, for her immeasurable commitment and her valuable assistance in organizing each facet of the project; to Ronald Pisano, curator, and his assistant, Beverly Rood, who led the selection process with care and vision and for their indefatigable research resulting

in this catalogue. Special mention should also go to Lawrence Campbell at the League, who provided us with documentary photographs and attended to the completion of the catalogue photography. I am grateful to Christopher Crosman, Director of the Heckscher Museum, for bringing this project to our attention and for working out so many of the details which have assured its successful completion.

The entire staff at the Gallery Association deserves a special round of thanks for hard work on this exhibition and for displaying their manifold talents over and over again. Helen Kebabian, Special Projects Coordinator, for editing the catalogue and exhibit text; Sabrina Vourvoulias, Film Coordinator/Exhibitions Assistant; David Ferguson, Registrar; Andrea Farnick, Registration Intern; and Kelly Fiske, Special Projects Coordinator, for assistance with arranging the tour and careful attention to all organizational details of the exhibition. Patricia Murphy, Designer, for designing the exhibit; Michael Lloyd and Gregory Matteson, Art Preparators, for fabricating the exhibit and crating the works. Donna Lamb, Art Transport Coordinator, with the Gallery Association's Driver/Art Handlers, Bill Burgess, Tony Carroccio, Scott Ogden, Nick Purdy, and Dave Ward are responsible for transporting the artwork safely to each site. My thanks to Kevan Moss, Executive Director, for her leadership and advice; and to Elizabeth Anderson, Development Director; Sue Bauman, Fiscal Manager, and Linda Trueworthy, Assistant to the Director, for all their assistance.

I would also like to express our appreciation to Anne Dobie Dutlinger for her sensitive design of the exhibition catalogue and to photographers Jacob Burckhardt and Rick Powers for undertaking the catalogue photography.

Constance Klein

Exhibitions Coordinator
Gallery Association of New York State

THE ART STUDENTS LEAGUE

Selections from the Permanent Collection by Ronald G. Pisano

Introduction

An unusual and very special aspect of the Art Students League of New York is, and always has been, its artistic atmosphere. Undoubtedly this can be attributed to the informal, non-academic structure of the school, where artists and art students—at all levels—work together to develop their work and exchange ideas, rather than to compete for grades and strive for diplomas. One member, Theodoros Stamos, commenting on the League's present setting (its permanent home since 1892), observed: "The League was a wonderful school to work in; and the studio atmosphere was, and is, very important for young artists to participate in." When asked about the significance of the school's collection as a part of the aesthetic whole of this setting, Stamos replied: "The collection of the League is a very important thing they have for students to study, and perhaps learn from." Stamos had only one reservation about the collection: "I think it could be better displayed."[1] His concern is one that has been shared by many other members. The main problem has always been a lack of sufficient space. Plans for future renovations should resolve this dilemma and at the same time provide better storage space for those works not on display.

In the meantime, this exhibition has been organized to reveal to the art world and the general public the significance of this historic collection, a very specialized collection closely linked to the League's development. The scope is broad, but the collection cannot be considered comprehensive. The missing links in the chain are easily identified and easily explained by the casual manner in which the collection has been formed. Just how this collection can be used most effectively, and most intelligently expanded to serve the League's members, is presently under consideration, and all are confident that the results will reflect the long and rich heritage of the Art Students League.

The small selection compiled for this exhibition is merely a sampling of the Art Students League's permanent collection of well over one thousand works of art. These paintings, prints, drawings and sculptures have been chosen to provide an overview of this extensive collection. Emphasis has been given to representative works of art from both the nineteenth and twentieth centuries. An effort has also been made to cover the various disciplines taught at the school. Unfortunately, the scale of this exhibition has precluded a fair representation of present and recent League instructors—easily an exhibition in itself.

I would like to thank all of the people who have assisted me in organizing this exhibition, especially those on the staff of the Art Students League: first and foremost, its dynamic Director, Rosina Florio, whose great enthusiasm and energy is to be both admired and envied; and Lawrence Campbell, who very generously provided valuable information and answered many questions relating to this essay. Others on the staff who have been particularly helpful are Herman Espada and Emily Smith.

I would also like to express my gratitude to Christopher Crosman, Director of the Heckscher Museum, for making this exhibition possible; and to the members of his staff who have assisted in its preparation, including Anne DePietro, Curator; William Titus, Registrar; and Nancy O'Brien, Administrative Assistant. I am also indebted to the Gallery Association of New York State for arranging for the show to travel to other museums and for assisting with many other details relating to the exhibition and catalogue: Kevan Moss, Executive Director; Constance Klein, Exhibitions Coordinator; and Helen Kebabian, Special Projects Coordinator. I would also like to thank David Cassedy for his preliminary editing of my essay; and Helen Farr Sloan for taking the time to read my essay and for her special interest in and continuing support of American art history.

Finally, I would like to acknowledge my very special appreciation for the help of my assistant, Beverly Rood, not only for the biographical essays she has written for the text, but for the additional work she performed on this project, including reviewing and assisting in the selection process, compiling the checklist and footnotes, overseeing correspondence, and offering suggestions and integrating editorial changes with regard to my own text.

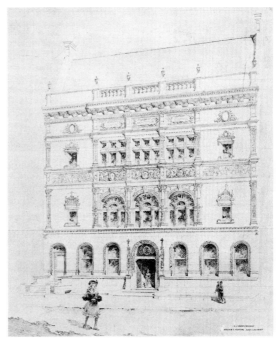

Henry F. Hardenbergh, *American Fine Arts Society Building*, ink architectural rendering, ca. 1889. (Some details of the facade were omitted to reduce construction costs.)

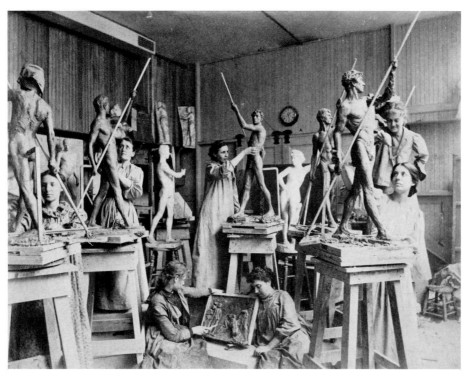

Augustus Saint-Gaudens class, 1892-93

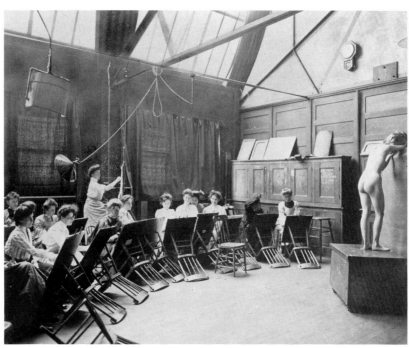

Women's life drawing class, ca. 1903

A Brief History of the Art Students League

Post-Civil War prosperity effected an artistic awakening in some sections of America, most notably New York City, which in the 1870s was rapidly becoming the artistic capital of the nation. Its major art institution, the National Academy of Design (founded in 1825), was one of the oldest organizations of its kind in America.[2] Representation in one of its annual exhibitions was a significant accomplishment for an artist; and election to full membership was indeed a paramount goal for many. By the mid-1870s, however, artists and art students in New York increasingly realized that the Academy was no longer adequate to serve the needs of their growing profession. Many young artists returning from their studies abroad were *au courant* with the most modern European developments. They felt that the established members of the Academy were conservative by comparison and thus unsympathetic to their relatively radical ideas and more sophisticated attitudes toward art. One progressive group found support at the home of Richard Watson Gilder, editor of *The Century Magazine*, and his wife Helena de Kay Gilder. The informal gatherings at which these artists exchanged ideas about art began as early as 1874 and climaxed three years later when they formed the Society of American Artists. In great part, this development reflected the conflict between the "old guard" at the National Academy and the young rebels: conservative versus progressive, insular as opposed to cosmopolitan. It was also prompted by the fact that there was just not enough exhibition space to accommodate the rapidly growing number of artists flocking to the city. The annual exhibitions of the Society of American Artists helped to alleviate this problem, and the Society itself provided the more progressive artists with their own forum.

A similar development took place in the spring of 1875, when it was rumored that the National Academy, due to financial difficulties, would cancel all classes until December. Students were alarmed. The Academy required them to devote the first ten weeks of each school session to drawing from the antique; so if this were true, they would not get to paint from life—their main interest—until February of the following year. Even more distressing was another rumor: if classes did resume, there might not be any instructor hired to direct them. The fact that their teacher Lemuel Wilmarth had not been asked to serve this function seemed to substantiate the story. Since there were no alternative means by which art students could engage in any formal course of study from live models, the students were particularly eager to deal with this dire situation before it was too late. They met with Wilmarth to discuss the matter. The result of their meeting was the formation of the Art Students League.[3]

From the start, it was evident that the founding of the Art Students League was precipitated by the possible cancellation of the Academy's classes. In addition, the students were dissatisfied with the rigid and limited course of study the Academy offered. They identified, and soon aligned themselves with, those artists who would soon form the Society of American Artists (and who would later become the chief instructors at the League). Like the National Academy, the League was established as a membership organization, but there was one major difference: unlike the Academy, where one had to be elected to a relatively small and elite group of artists, the Art Students League offered membership to any candidate with acceptable moral character and the means to pay his dues. The informal nature of the League's organization was also very different from that of the Academy. At first, the major concern of its organizers was the continuation of life classes and the need to secure a place in which to conduct them. Modest quarters were obtained at 108 Fifth Avenue, on the corner of Sixteenth Street. These quarters consisted of one half of a room measuring twenty by thirty feet. Within a month's time, attendance had risen to approximately

seventy students, and the other half of the room had to be rented as well.[4] Classes of three hours' duration were held daily, with afternoons reserved for women and evenings allocated to male students.[5] Tuition, the sole support of the school's activities, was set at five dollars per student per month.

The casual, club-like nature of the League was not merely the result of the impromptu nature of its formation; its original objectives as stated in writing in 1875 underscore its democratic intent: "the encouragement of a spirit of unselfishness among its members; the imparting of valuable information pertaining to Art as acquired by any of the members . . . mutual help in study, and sympathy and practical assistance (if need be) in times of sickness and trouble." From the start it was clear to the League's founders that such a strong bond of cooperation was essential to the success of this daring venture, precariously funded by its membership fees alone. It was a unique undertaking, the only independent art school in the country, and the only one in which the life class, a crucial element, was available every weekday. Survival of the school was a critical concern of all its members.

At first there was great enthusiasm and optimism; then, in the spring of 1877, the National Academy announced that it would resume its classes the next season. Furthermore, it would offer three life classes a week (an option undoubtedly prompted by the students' recent protest). Since the Academy's classes would be, as in the past, free of charge, this proclamation presented a very real threat to the League's fragile existence. A further complication was a statement from the League's president and instructor, Lemuel Wilmarth, that he would return to the Academy to oversee its revised program of instruction. Was there any further need for the League? Was there enough serious interest in its programs for it to survive? On April 27, 1877, the students held a meeting to address the major issue: *Shall the students return to the Academy to study next year?*" The response was

an emphatic *"No."* Frank Waller was elected the new president, and Walter Shirlaw became the chief instructor. Classes resumed in October of 1877. The third year of the League's existence (1877/78) was not encouraging—there was no increase in enrollment, and the year ended with a debt. Each member was charged an additional $2.50 to make up the loss.

It was clear that the 1878/79 school year would be the true test, and the school's leaders geared up for the challenge. The League was incorporated on January 31, 1878. Frank Waller, serving his second term as president, explained the reasons: "Incorporation," he said, "tends to give the society a permanence, and therefore to each member a confidence in it which is of greatest importance to its success. It effectually prevents the life school, and therefore the society, from being possibly at the mercy of any inimical person; it secures to the society the advantages of any bequest or gift, by permitting it to hold property, and it makes each member responsible for its debts or sharer in the accumulations, and this binds us together in its downfalls or entitles each to glory in its success."

With incorporation came a constitution and by-laws establishing a Board of Control. The new structure called for a president, two vice-presidents (one woman nominated by the female members, and one man, nominated by the male members), and three others. These six board members were then authorized to select six additional members, each to serve for a period of one year. Most importantly, at least one-third of the Board of Control had to consist of currently enrolled students at the League. This revolutionary stipulation assured students of a part in guiding the future course of the organization and granted them power in making decisions that would seriously affect their own development as artists.

The prospectus for 1878/79 announced the League's "first full faculty." Walter Shirlaw was to teach composition; Jonathan Scott Hartley, modeling; Frederick Dielman, perspective; and William Merritt Chase was hired to supervise the most important course, drawing and painting. Although his name does not appear on the prospectus, J. Carroll Beckwith was engaged to conduct the antique class, presumably a late addition to the curriculum.[6] The League also altered its admission policy, making it mandatory for students to pass a test by submitting a drawing of a full-length figure from a cast or from life before being admitted to the life class; a drawing of a head from cast or life, for the portrait class; or an original design for the composition class. This new policy was undoubtedly intended to stress the serious nature of the school.[7]

The school's new image was emphasized by Charles Yardley Turner, chairman of the school committee, in a report he prepared for the press in 1879. In this study, he claimed that the cumulative hours of teaching available at the League for the past year's session was 3,725. The significance of this statement was made clear in an article published in the *Evening Post* which elucidated: "so far as is known, the greatest number of hours similarly devoted in any other American institution is only four hundred and thirty two." Equally reassuring was the fact that the League not only met the financial demands of an expanded faculty, but ended the year with a surplus of $1,800.

The League's importance and its public recognition was greatly enhanced by its chief instructor, William Merritt Chase, who began teaching in 1878. Recently returned from his own studies in Munich, Chase was already heralded as "one of the most thoroughly trained and vigorous of the painters whose work has within a year or two excited so much remark and interest here."[8] As president of the rebellious Society of American Artists, Chase was a controversial and articulate spokesman for the progressive movement in art, and his own bold method of painting attracted considerable public attention. Furthermore, Chase proved to be a natural teacher. He was widely acknowledged as a master technician, and he forcefully conveyed his knowledge of materials and technique to his many pupils. Of equal importance was his ability to instill enthusiasm in his students. During the years he taught at the League, he was beyond doubt the most popular teacher there, and in great part his presence contributed to the League's future success.

Initially, some feared that Chase's vital personality and vigorous approach to painting would be overwhelming, putting too much emphasis on the methods of the Munich school, while sacrificing the careful drawing stressed in Paris. One writer even predicted that Chase and Shirlaw, who also had been trained in Munich, would "turn out many a Frans Hals [Munich-trained artists greatly admired this old master] from among the lively crowd of American disciples."[9] However, the League's policy was to offer a broad range of artistic study, favoring no particular school or specific approach to painting, allowing its students to choose their own courses of study. Over the succeeding decades the balance between Munich and Paris-trained artists serving as instructors was carefully maintained, and was largely responsible for the

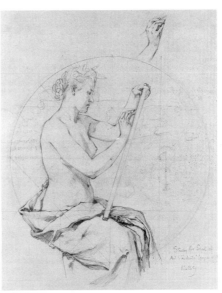

Kenyon Cox, Study for Art Students League seal, 1889

League's continued popularity. In the early 1880s, Paris-trained artists William Sartain, Kenyon Cox, George de Forest Brush and J. Alden Weir were hired. The presence of these Paris-trained instructors was balanced by the Munich-trained Walter Shirlaw (who had returned in 1883 after a leave of absence). Frederick Freer and Thomas Dewing, who had studied in both Paris and Munich, also joined the staff.

As the League continued to prosper, it required larger and better facilities, and the school moved on several occasions to accommodate rapid growth. In 1882, management of the League began to change in response to expanding programs and changing needs. A surplus of $1,500 was realized that year and set aside in a special fund for investment. The president of the League, William St. John Harper, had the foresight to advise that the school should project a similar profit for future years that could be invested as well, until the principal amounted to $10,000. This fund could then be used to offset deficits in future years. Furthermore, Harper felt that additional managerial assistance was needed, and insisted that a businessman be engaged to help the treasurer and various school committees—duties previously undertaken voluntarily by members. The same year the League moved to 38 West Fourteenth Street, between Fifth and Sixth Avenues, where they leased the upper three floors of a building.

In January of 1885, the League awarded its first scholarship for study abroad (further bonding its links to European training), the Harper-Hallgarten Scholarship. In the fall of that year, Frank Waller, the League's president, appealed to additional benefactors and patrons for similar contributions, and proclaimed that a "higher standard could be maintained by not making popularity a means of support" for the school. He also pointed out that the League was now "thoroughly organized, has a good corps of instructors, gives more hours of study from live models than any other school in the United States, and under the management of the students themselves has been self-sustaining for ten years, without one cent of debt."

Two years later, in 1887, the school moved once again, this time to 143-47 East Twenty-third Street. By this time, the League was so widely known that its enrollment was reported to represent students from "every state in the union except four, and from the territories and Canada as well." In spite of this impressive claim, and the move to a new and larger space, it was soon obvious that accommodations were still inadequate. One student reported that rats came out from the stacks at night to eat the crumbs left behind by the bread erasers used in the drawing classes; and nearby stables and a sewer gas leak were responsible for foul odors.[10] Another move was inevitable—this time, after two years of deteriorating conditions, it was hoped that a proper and permanent building could be obtained. Other art associations in New York with similar problems united with the League to form the American Fine Arts Society, an independent group which was incorporated in June 1889. Together with these organizations—the Society of American Artists, the New York Architectural League, the Painters in Pastel, and the New York Art Guild—the Art Students League planned to build a new facility. A site was selected on Fifty-seventh Street, between Broadway and Seventh Avenue. The architect was Henry J. Hardenbergh, now best known for his designs for the Plaza Hotel (1907) and the

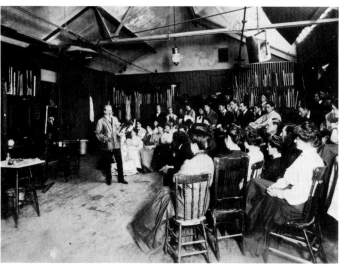

William Merritt Chase paints a demonstration still life, ca. 1907-8

Dakota apartment house (1884). The building was completed in 1892, and the League moved into its new—and permanent—headquarters at 215 West Fifty-seventh Street. An exhibition gallery, which was first used by the Society of American Artists and later by the National Academy of Design, was added to the back of the building with funds provided by George W. Vanderbilt.[11]

During the following decades the League enjoyed a measure of success and endured some notable controversies as great personalities in American art guided the next generation of our country's important painters. One significant upset occurred when William Merritt Chase resigned in 1896. The problem was reported to be a matter of philosophy—Chase challenged the custom of requiring beginning students to draw from the antique, insisting that drawing directly with the brush was a superior means of learning to paint. The conservatism of the Paris-trained artists, particularly Kenyon Cox, prevailed, so Chase formed his own school, the Chase School (later renamed the New York School of Art).[12] His overwhelming popularity as a teacher, in addition to the fact that most students (like Chase in his own student days) abhorred drawing from antique casts, assured the success of the new school, which presented a major threat to the well-being of the League. By 1902/03, the League's president, Samuel Shaw, was concerned that his institution might actually collapse as a result of Chase's defection. To prevent this, he called upon another popular instructor, Frank Vincent DuMond, to conduct the painting class at the League. DuMond, who was well-known as a teacher at both the League and Chase's school, accepted the position—with the stipulation that there be no entrance requirements for his classes. Thus, the major differences in the formats of the two schools were minimized. As a result, the League grew stronger. Chase also faced other problems, as Robert Henri, one of his chief instructors, challenged his authority. Unlike Chase, whose philosophy was "art for art's sake," Henri preached a new doctrine—"art for life's sake." The mounting friction between the two artists, along with the school's financial difficulties, finally prompted Chase to leave the school he had founded and return to the League in 1907. This was easily accomplished without sacrifice of any of his principles, since the League had changed its position on the very issue that had caused Chase to resign. Now students could enroll in his painting classes without meeting any prerequisites.

Upon returning to the League, Chase reported enthusiastically: "My classes at the League are large, and, what seems to me more flattering and hopeful for the future of art, there are more men in my classes than I have ever had before."[13] This statement was not meant to be a misogynist one, although it may be considered somewhat defensive. Women, including a fair number of amateurs, had dominated Chase's classes for years. However, whether in male or female students, Chase recognized true talent when he saw it, and he was quick to acknowledge any student's abilities. In 1908, while teaching at the League, he awarded Eugene Speicher a scholarship prize for the best work in his portrait class, *Portrait of Georgia O'Keeffe;* and in his still life class, Georgia O'Keeffe herself was awarded a scholarship for her painting *Dead Rabbit and Copper Pot.* Although the two art students went on to develop very different styles of painting, their special talents have been proved beyond doubt, and both acknowledged their debt to Chase, for inspiration and for sharing his unparalleled knowledge of technique. O'Keeffe, who became one of America's most famous modernist painters, recalled her early days as a Chase student at the League: "When he entered the building a rustle seemed to flow from the ground floor to the top that 'Chase has arrived.'" She also explained: "I think Chase as a personality encouraged individuality and gave a sense of style and freedom to his students."[14]

In 1915, four years after Chase had ceased teaching at the League, Robert Henri joined its staff. Although

their philosophies of art were still very different, their spontaneous approach to painting and their inspiring personalities were actually very similar. Henri had his share of admiring students as well. One, Helen Appleton Read, recalled: "He tried to wean us away from the idea that we were art students, a state which immediately causes scales to grow over one's eyes, and to see things again as ordinary human beings."[15] Marjorie Ryerson, another of Henri's League students, honored her mentor by compiling a compendium of notes taken by various Henri students and publishing it in the form of a book—*The Art Spirit*. Chase, considered radical in his early days at the League, retired a gentleman-artist. Henri's equally vital personality and those of his friends and followers catapulted the League into the twentieth century.

During the 1920s and '30s, Robert Henri and his associates represented a major influence at the League, both in terms of instruction and in the school's politics. Henri's own tenure lasted over a decade (1915-28). Even before he started teaching at the League, his close friends had been conducting classes there: Everett Shinn (1906/07), and George Bellows (1911, 1917-19). In 1920, George Luks began teaching there and continued to do so for four years. William Glackens also lectured at the school during this period. The most influential of the group, aside from Henri, was John Sloan, who taught at the League from 1914 until 1938 (with short breaks). The fact that these strong personalities—whose painting styles were similar—held prominent positions does not mean that the school advocated any particular style of painting or philosophy of art. During this very same period, more abstract forms of painting were taught in the classes of Max Weber (1919-21, 1925-27), Vaclav Vytlacil (1928/29, 1935-81, with short breaks), Jan Matulka (1929-31), Stuart Davis (1931-32) and Hans Hofmann (1932-33). In fact, John Sloan, upon accepting the post of president in 1931, attributed the great success of the League to the fact that it "furnishes such a varied menu of nourishment for the

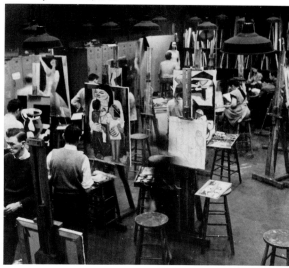

Vaclav Vytlacil class, 1948

hungry art student, ranging from the conservative to the ultra-modern."

During this active period of the school's development, the League continued to expand both its academic programs and its facilities. In 1921, Joseph Pennell was hired to teach printmaking and reportedly transformed the "barren and bleak" etching studio into an active classroom with presses busily churning out students' prints.[16] Graphic arts continued to be an important part of the school's program in the 1930s and '40s with acknowledged masters such as Martin Lewis and George Picken supervising the presses. As attendance grew, the League sublet the second floor of the building from the Architectural League; another floor had already been added for additional studio space.

Although the school had no official spokesman, John Sloan continued to have a powerful influence throughout the 1930s. His philosophy of art and his teaching principles were well known by many of the League's students, who took copious notes. This material was diligently gathered by one of Sloan's students, Helen Farr (who later became his second wife). The result of her work was a book, *Gist of Art*, first published in 1939. This book made Sloan's thoughts on art available far beyond his own classes, and has served as a useful tool and source of inspiration for succeeding generations of art students. One major controversy

that arose in 1932 during Sloan's tenure as president concerned the proposed hiring of the painter George Grosz, then living in Germany. Sloan strongly supported this idea, stating: "He is a modern who shows a thorough academic training." When the Board of Control voted down his proposal, Sloan resigned, criticizing his colleagues for letting politics bias their decision. Later that spring, he volunteered to resume his post if voted back in by the students. Although Henry Schnackenberg was elected instead, Sloan won another victory—the decision on Grosz was soon reversed and he was hired as an instructor. Sloan returned as an instructor himself in 1935.[17]

Indeed, a major reason for the Art Students League's continuous success is its long line of dedicated teachers and loyal and appreciative students, many of whom subsequently returned to the League themselves to teach. Testimonials to this effect are innumerable, but a few will suffice to illustrate this point. Allen Tucker, who first came to study at the League in 1890, was impressed both by the unconventional nature of the school's structure, and by one of his teachers, John H. Twachtman: "The League was a place to work, and a great man came twice a week to help you with that work. It was, of course, good fortune beginning under Twachtman, for not only was he one of the great men of his time, but one of the best teachers that ever was, somehow instilling into people the idea of the greatness and nobility of the thing called art."[18] Years later, in 1921, Tucker returned to the League as a teacher and had a similarly inspiring effect on his own students. One, Theresa Pollack, recorded her impressions: "But most of all, there was for me the gentleman and true aristocrat of them all, Allen Tucker. A great man of dignity, tall in stature, he would step from the taxi on criticism days in high hat, gray striped trousers and black coat with tails; but there was nothing 'stuffy' about him. He brought to the class the real meaning of art, as perhaps no other teacher could . . . he looked at each of us as though we mattered, and existed for him as individu-

als."[19] Most recently the artist Stephen Greene expressed similar feelings about the Art Students League and the strong personal bonds maintained by its instructors: "The League's relationship to its faculty is always one of respect and loyalty. I remember seeing Edwin Dickinson, a truly dignified man . . . the day he handed in his resignation and saying as he walked out, 'Now, I'm going home to weep.' It speaks of an affection which many of us who taught at the League have for the place and for those who help make it possible."[20]

It is evident in such statements that there were very strong ties between teachers and students at the League, personal bonds that can be traced back to the founding principles of the school, as embodied in its certificate of incorporation in 1878. This document lists as one of the League's primary objectives: "the encouragement of a spirit of fraternity." The League was and still is a cooperative society based on mutual help among all its members. There have never been any degrees or diplomas, no set curriculum; one must be there solely for the love and pursuit of art, the yearning for the exchange of artistic ideas and techniques. It is an institution founded by students for students, and these are the major reasons the school has continued to flourish.

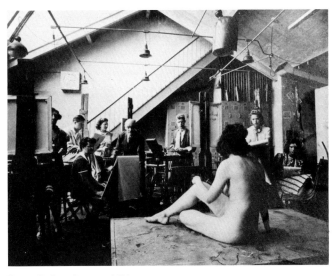

George Picken class, ca. 1930s

Notes

[1] Theodoros Stamos, letter to Ronald Pisano, April 2, 1987.

[2] The Pennsylvania Academy of the Fine Arts, Philadelphia's counterpart to the National Academy of Design, was founded in 1805. Other similar organizations were formed earlier (in the eighteenth century) but were short-lived.

[3] Unless otherwise noted, the history of the League and quotations have been taken from Marchal E. Langren, *Years of Art: The Story of the Art Students League of New York* (New York: Robert M. McBride & Co., 1940). Efforts have been made to avoid duplicating possible errors contained in Langren's text; this accounts for inconsistencies that may exist between Langren's history and this essay. Lawrence Campbell of the League has provided corrections and supplemental information in some cases.

[4] By the end of the first year the League had taken over the whole floor, and they ultimately used the two top floors, according to Campbell.

[5] This was the first and only life class available to women in New York at the time, according to Campbell.

[6] J. Carroll Beckwith, unpublished diary, 1878 (National Academy of Design, New York) discusses his teaching at the League during the fall of that year.

[7] The life class was the most serious class, and standards for admission were the most exacting, according to Campbell. A student had to have experience in drawing from the antique or the equivalent in order to enroll, and to become a member of the League one had to qualify for the life class. The antique class was introduced to "feed" the life class.

[8] William C. Brownell, "Art Schools of New York," *Scribner's Monthly* 16, no. 6 (October 1878), p. 777.

[9] "The Art Students League," *Art Amateur* 2, no. 2 (January 1880), 24.

[10] *The Kennedy Galleries Are Host to the Hundredth Anniversary Exhibition of Paintings and Sculptures by 100 Artists Associated with the Art Students League of New York*, foreword by Lawrence Campbell (New York: The Art Students League of New York, 1975), p. 19; *American Masters: Art Students League* (New York: Art Students League of New York, 1967), pp. 14-15; Langren, *Years of Art*, p. 48. The infestation of rats occurred at the Fifth Avenue space, not on 23rd Street, according to Campbell.

[11] Vanderbilt built the gallery for his own use, according to Campbell, but later donated it to the American Fine Arts Society.

[12] Campbell feels that Frank Vincent DuMond was the first to insist on dispensing with the entrance requirements. Chase opened his new school without demanding his students draw from the antique, however, and as DuMond was a colleague at both schools, it seems likely that they had similar feelings about the subject at the same time.

[13] "Wm. M. Chase Forced Out of New York Art School, Triumph for the 'New Movement' led by Robert Henri," New York *American*, November 20, 1907, p. 3.

[14] Georgia O'Keeffe, letters to Ronald Pisano, August 18, 1972 and September 18, 1972.

[15] William I. Homer, *Robert Henri and His Circle* (Ithaca, New York: Cornell University Press, 1969), p. 150.

[16] *One Hundred Prints by 100 Artists of the Art Students League of New York, 1875-1975*, foreword by Judith Goldman (New York: The Art Students League of New York, 1975), p. 16.

[17] According to Campbell, Sloan substituted for Thomas Hart Benton in 1933.

[18] *American Masters*, p. 15.

[19] *Hundredth Anniversary Exhibition of Paintings and Sculptures*, p. 23.

[20] Stephen Greene, letter to Ronald Pisano, April 14, 1987.

Selections from the Permanent Collection

Arthur Wesley Dow

b. 1857 Ipswich, Massachusetts
d. 1922 New York City

Arthur Wesley Dow received his first formal art instruction in 1880. His training began in earnest the following year in Boston, and in 1884 he embarked for Paris, where he enrolled at the Académie Julian. Over the next few years he spent a portion of each year at Pont Aven in Brittany, where, inspired by the French Barbizon school, he painted landscapes out-of-doors. He settled in his native Ipswich in 1889, where the picturesque countryside afforded Dow many opportunities to paint pleasant views with a muted palette, similar to *Landscape.*

Dow's discovery of Japanese woodblock prints in 1891 was a turning point leading to the development of a lifelong friendship and collaboration with Ernest F. Fenollosa, then curator of the Japanese Department at Boston's Museum of Fine Arts. Dow became his assistant in 1893, and then curator himself in 1897. In the meantime he had begun conducting classes in Ipswich and Boston, where he taught the principles of design he had formulated based on his study of Japanese prints. In 1895 Dow and Fenollosa were both appointed to the faculty of Pratt Institute, and in 1899 Dow began lecturing at the League, where he continued for four years. He later taught for many years at Teacher's College, Columbia University. Over his long career, Dow's innovative teaching principles and writings influenced modernist artists such as Georgia O'Keeffe and Max Weber. As one writer explained, Dow "humanized" art instruction, and "cleared a path through the jungle of academic theories that hampered the progress of art" at the end of the nineteenth century.[1]

LANDSCAPE, 1889

oil on canvas, 17¾" x 32"
Purchase, 1985

[1] George J. Cox, "The Horizon of A. W. Dow," *International Studio* 77 (June 1923), 189; see also Frederick C. Moffat, *Arthur Wesley Dow (1857-1922)* (Washington, D.C.: Smithsonian Institution Press, 1977).

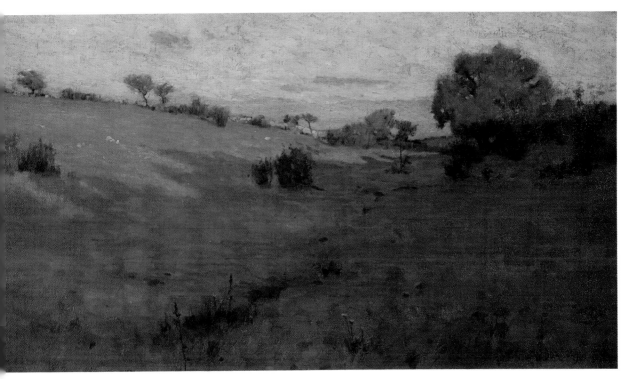

NDSCAPE

Kenyon Cox

b. 1856 Warren, Ohio
d. 1919 New York City

Kenyon Cox began his formal studies in the early 1870s at the McMicken School of Design in Cincinnati. In 1876 he worked briefly at the Pennsylvania Academy of the Fine Arts. He completed his training in Paris, working for a short time with Carolus Duran and then at the École des Beaux-Arts and the Académie Julian. In 1882 he settled in New York City and became known as a painter, illustrator, art critic and teacher, and most emphatically as a champion of classical principles in art. During the 1880s he painted mostly nudes and landscapes, and in the '90s he embarked on a career as a mural painter, a perfect format for his idealized and intellectual approach.

Cox taught life, anatomy and antique classes at the League from 1885 to 1909. His rigorous academic standards made him an intimidating figure in the classroom. One writer indicated that "his teaching countered sharply the restless spirit of the time."[1] If Cox's dogmatic style did not make him a popular figure, his emphasis on the basics of composition, draughtsmanship, and studying art of the past were an important contribution.

[1] Frank Jewett Mather, *Estimates in Art* (New York: Henry Holt, 1931), 295; see also Doreen Bolger Burke, *American Paintings in The Metropolitan Museum of Art, Volume III: A Catalogue of Works by Artists Born Between 1846 and 1864*, ed. Kathleen Luhrs (New York: The Metropolitan Museum of Art, 1980), 213-19.

STUDY FOR THE SEAL OF THE ART STUDENTS LEAGUE OF NEW YORK, 1889

pencil on paper, 20⅜" x 16¾"
Gift of Allyn Cox, 1959

NUDE

oil on canvas, 30" x 18"
Gift of the artist

MURAL STUDY

pencil on canvas, 24¼" x 28¼"
Commissioned by the American Fine Arts Society

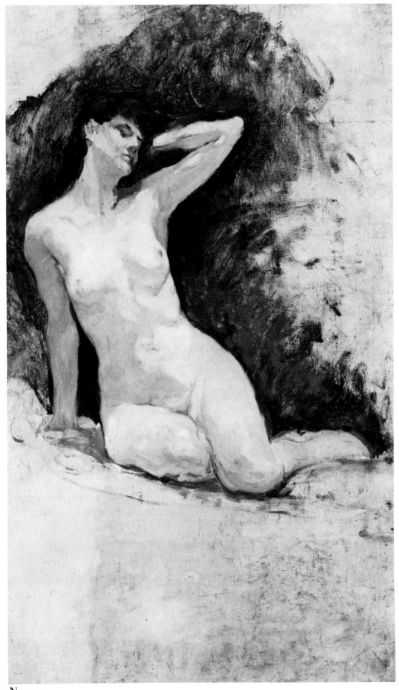

NUDE

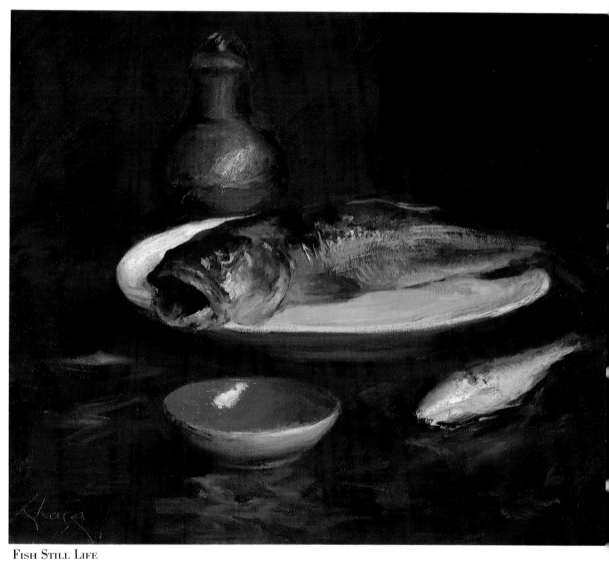

FISH STILL LIFE

William Merritt Chase

b. 1849 Williamsburg, Indiana
d. 1916 New York City

In 1878, after six years of study in Munich, Chase returned to America to teach drawing and painting at the League. Chase's dazzling technical skill and dynamic personality helped the League grow into a thriving institution. Enrollment jumped from less than a hundred pupils in 1877 to four hundred by 1883. Except for the 1885-86 season, Chase taught at the League until 1896, when he dismantled and sold the contents of his celebrated 10th Street studio and embarked for Europe. He returned to found his own school, known as the New York School of Art. In 1907, however, a dispute with Robert Henri, who had become a popular instructor, led Chase to resign and return to the League, where from 1907 to 1912 he taught portrait and still life painting.

To many, the most memorable aspect of Chase's teaching was the demonstration piece. Dressed in an impeccable suit, Chase would "attack" a canvas, and swiftly lay in a still life or portrait study in as little as an hour, giving a dramatic display of his bravura technique. His *Fish Still Life* is a typical example. Chase painted still life throughout his career, and was a master at representing various textural qualities. After the turn of the century, he especially delighted in painting still lifes of fish. These paintings commanded high prices, and were sought after by museums and collectors. Chase's choice of subject demonstrates a belief he often repeated to his students: that the humblest object was worthy of being painted, so long as it was painted well.[1]

See Ronald G. Pisano, *A Leading Spirit in American Art: William Merritt Chase, 1849-1916* (Seattle, Washington: Henry Art Gallery, University of Washington, 1983).

FISH STILL LIFE, ca. 1908

oil on canvas, 26¼" x 30½"
Gift of the artist

Frederick W. Freer

b. 1849 Kennicott's Grove, Illinois
d. 1908 Chicago, Illinois

After a brief period of artistic study in Chicago, Frederick Freer went to Munich in 1867 and worked for the next five years at the Royal Academy. In 1872 he returned to Chicago, but was able to resume his studies in Munich and also in Paris in 1877. In Munich, Freer became friendly with Frank Duveneck, J. Frank Currier and other American artists working there. It is likely that Freer first met William Merritt Chase at this time. In 1880 Freer settled in New York City, where he undoubtedly renewed his acquaintance with Chase, who was teaching at the League. He traveled to Europe with Chase in 1883, and it is possible that Chase was responsible for Freer's assuming a teaching position at the League in 1885-86.[1] In 1892 Freer moved back to Chicago, where he taught at the Art Institute and later became director of the Chicago Academy of Design.[2]

Head of a Man was probably painted while Freer was copying old master paintings (a common practice for artists of the period) as a student in Germany or possibly on a later trip to Europe. It is likely that Freer donated his work to the League in accordance with the policy adopted in 1882 soliciting such paintings from members who were traveling abroad.

[1] This date was provided by Lawrence Campbell.
[2] David C. Huntington and Kathleen Pyne, *The Quest for Unity: American Art Between World's Fairs, 1876-1893* (Detroit: The Detroit Institute of Arts, 1983), 111-12.

HEAD OF A MAN

oil on panel, 8¼" x 6¼"
Gift of the artist

James Carroll Beckwith

b. 1852 Hannibal, Missouri
d. 1917 New York City

Carroll Beckwith, as he preferred to be known, arrived in New York in the fall of 1878, fresh from five years of study in Paris. While in Paris, Beckwith studied briefly with Leon Bonnat, took drawing classes at the Ecole des Beaux-Arts, and worked primarily under Carolus Duran. Upon his return to America, Beckwith accepted a post at the League as instructor in drawing from the antique, and in 1879 he returned to Europe to purchase a complete set of plaster casts for use in this class. Beckwith taught at the League from 1878 to '82, and from 1886 to '97. An article in *Art Amateur* described him as "a strenuous opponent of the great tide of facile art which has invaded, not only the [League] but the country." Beckwith's emphasis on drawing countered a "very wild sort of impressionism" which the Munich-trained instructors (W.M. Chase and Frederick Dielman) supposedly encouraged. The writer was quick to point out, however, that Beckwith was "a prime social favorite with the very instructors whom it is his business to nullify."[1] Indeed, Beckwith and Chase in particular were life-long friends and collaborated on many important projects.

Beckwith's engaging personality and willingness to work for causes furthering American art landed him on many committees. In the spring of 1889 he joined Howard Russell Butler and others to raise money for the construction of a building to house the Art Students League, the Society of American Artists, the Architectural League and the Art Guild. He and Butler worked tirelessly for three years soliciting money from wealthy but not always generous patrons, and in the fall of 1892 the American Fine Arts Society opened its doors on 57th Street, and has remained the League's quarters.

Beckwith concentrated on portraits and figure studies throughout his career, and rarely painted still life or pure landscape. *Drying Fish Nets, Cannes* is a late work, painted during a year-long trip to Europe in 1910-11. This small panel, freely painted out-of-doors in a high key, represents Beckwith's attempt to renew his artistic vigor abroad after years of dedicating himself to promoting American art in New York.

[1] Edward Strahan [Earl Shinn], "James Carroll Beckwith," *Art Amateur* 6 (April 1882), 95.

DRYING FISH NETS, CANNES, 1911

oil on panel, 13½" x 10⅛"
Purchase, 1987

Frank Vincent DuMond

b. 1865 Rochester, New York
d. 1951 New York City

Frank Vincent DuMond's remarkably long association with the League began in 1885 in J. Carroll Beckwith's antique class. While working as an illustrator, DuMond spent another month in Beckwith's class and also studied with William Sartain during the 1886-87 season. He continued his training in Paris at the Académie Julian, and then returned to New York and accepted a teaching post at the League in 1892. He taught until 1894; in 1902 he was asked to return to the League, and he taught there until his death in 1951. His many students remembered him as a generous, kind man who enjoyed teaching and went out of his way for them. For example, he held an extra late-afternoon session once a week in the League's basement, where former and current students brought their paintings for criticism. His talks were philosophical and often touched on areas other than painting. DuMond defined his role in this way: "We are all in a strange forest, and because I have been here longer, I am to guide you part of the way. Reaching that, I will tell you what I think is ahead. From there, it is yours to go on."[1]

DuMond painted murals, portraits, and symbolist works like *Joan of Arc* throughout his career, but he is most associated with landscape. DuMond said: "The place where one is most in tune with the source – the nature of the world – is outdoors."[2] The crisp style, electric color, and intense light of his outdoor work can be seen in *Forest Sentries*.

[1] Herbert E. Abrams, "The Teachings of Frank Vincent DuMond: Penetrating Light," *American Artist* (March 1974), 67.
[2] Ibid., 65-66.

JOAN OF ARC

oil on canvas, 19¾" x 15¾"
Gift of Paul Hiller, 1964

FOREST SENTRIES, ca. 1940-42

oil on canvas, 28" x 30"
Purchase, ca.1950

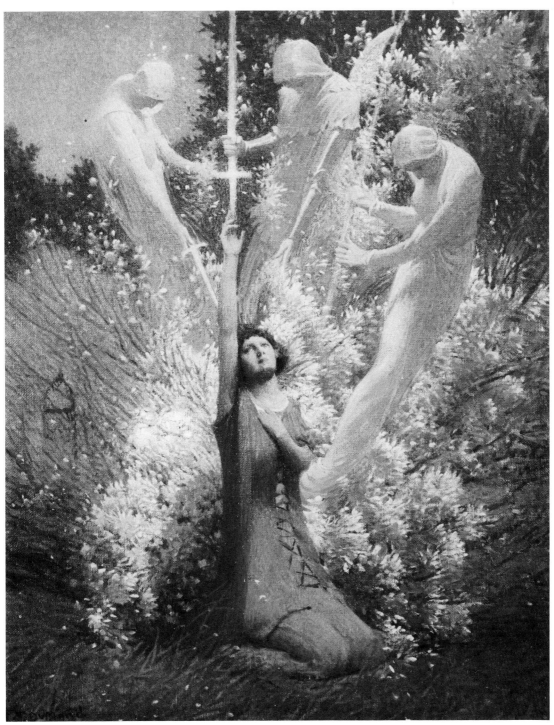

JOAN OF ARC

Alfred Quinton Collins

b. 1855 Portland, Maine
d. 1903 Cambridge, Massachusetts

Alfred Collins studied in Paris at the Académie Julian and with Leon Bonnat. As a mature artist he specialized in portraiture, working mostly in Boston, San Francisco and Buffalo, and visiting Europe periodically to stimulate his work. In the late 1880s and early '90s he was active in New York City, at which time he painted this sensitive portrait of Joe Evans, who served as President of the League from 1891 to '93. This painting was exhibited as Collins's sole entry in the World's Columbian Exposition, held in Chicago in 1893. Collins's precise, refined technique was overlooked by his generation, which, as a reviewer of the Brooklyn Museum's memorial exhibition pointed out, preferred "fashionable dash and bravura."[1] Collins destroyed much of his work shortly before his death, and his paintings are rare.[2]

PORTRAIT OF JOE EVANS, 1890

oil on canvas, 26¼" x 21"
Gift of the artist

[1] "Alfred Quinton Collins, A.N.A.," *The Brooklyn Museum Quarterly* 12, no. 2 (April 1925), 97-98.

[2] See Doreen Bolger Burke, *American Paintings in The Metropolitan Museum of Art, Volume III: A Catalogue of Works by Artists Born Between 1846 and 1864*, ed. Kathleen Luhrs (New York: The Metropolitan Museum of Art, 1980), 176-78.

Joseph Pennell

b. 1857 Philadelphia
d. 1926 Brooklyn, New York

Joseph Pennell began his career as an illustrator after studying at the Pennsylvania Academy of the Fine Arts and the Pennsylvania School of Industrial Art. He went to Europe in 1883 and spent much of the next thirty-four years abroad, mostly in England. During extensive travels in the 1880s and '90s, Pennell made prints and sent them to American periodicals; this work helped popularize the illustrated travel-adventure story. Pennell was a close friend and biographer of James McNeill Whistler, and adopted some of his graphic techniques such as working directly from nature and experimenting with tonal effects. Many of Pennell's prints depict large-scale construction work, such as his famous Panama Canal series and his New York scenes.[1]

After the turn of the century, Pennell became the most prominent figure in American printmaking, working constantly to promote the teaching and appreciation of printmaking as a fine art. In 1922, five years after Pennell returned to the United States permanently, Gifford Beal asked him to take over the League's etching class and to start a lithography class. Pennell's wife later wrote that "At the League he was asked not to talk, but to teach; his time was limited not to one hour, but to one morning a week." Pennell thought of teaching as an "important" opportunity.[2] Over the next four years he persuaded commercial printers to provide equipment and tools for his classes. He also expanded the school's program by inviting Charles Locke and Allen Lewis to teach classes in lithography and woodcutting, respectively. Pennell's ultimate vision of an "American School of the Graphic Arts" was cut short by his death in 1926.

CITY SCENE

etching, 8¾" x 14¾"
Gift of the artist

[1] See James Watrous, *A Century of American Printmaking, 1880-1980* (Madison: The University of Wisconsin Press, 1984), 28-43.
[2] Elizabeth Robins Pennell, *The Life and Letters of Joseph Pennell*, vol. 2 (Boston: Little, Brown, 1929), 271.

Ernest Lawson

b. 1873 Halifax, Nova Scotia
d. 1939 Miami, Florida

Ernest Lawson studied at the Kansas City Art League School in 1888, and spent one month at the San Carlos Art School in Mexico City the following year before coming to New York City. He entered the League in 1891, attending both morning and evening sessions of John Twachtman's preparatory class during 1891-92. Lawson also studied with Willard Metcalf, H. Siddons Mowbray and J. Alden Weir. Lawson continued his studies with Weir and Twachtman at their summer art school in Cos Cob, Connecticut, and completed his training at the Académie Julian in Paris in 1893. *Sunrise* is likely an early work, painted while Lawson was influenced by Weir, Metcalf and Twachtman, all admirers of the French Impressionists. Its serene mood and pale tonal palette relate most closely to Twachtman's work.

Success came readily to Lawson in the early part of his career. In 1907 Robert Henri hailed him as "the biggest man we have had since Winslow Homer."[1] In his mature work Lawson developed a concern for form and structure and a grainy, textural way of painting that went beyond the broken brushwork of Weir or Metcalf.

[1] Henry and Sidney Berry-Hill, *Ernest Lawson — American Impressionist, 1873-1939* (Leigh-on-Sea, England: F. Lewis, 1968), 26.

SUNRISE

oil on canvas, 20" x 28"
Provenance unknown

Allen Tucker

b. 1866 Brooklyn, New York
d. 1939 New York City

After graduating from Columbia University, Allen Tucker studied at the League from 1890 to 1895, primarily with John Twachtman. Tucker later recalled: "there was a relentless drive to the place that I had never before felt anywhere. For the first time it was put up to me to learn. . . . I was let alone without having attendance and deportment marked, in short, with confidence and respect."[1] After working as an architect for about nine years, Tucker turned to painting full time in 1905, working in an impressionistic style derived from Monet, as can be seen in his painting *October Cornfields.* Tucker became friendly with the group of artists known as "The Eight," and in 1911 was a founding member of another anti-academic group, the Association of American Painters and Sculptors. This group organized the Armory Show in 1913, in which Tucker exhibited five paintings. By about 1914, his work began to show the influence of Van Gogh in both content and style. Startling color, thickly applied paint, expressive form defined with heavy line, and an increasingly visionary subject matter all derive from his great admiration for Van Gogh's work.[2]

Tucker taught at the League from 1921 to 1928. One student, Theresa Pollack, remembered that "in his great respect for the freedom and integrity of the artist, he never touched our work. . . . Each week he brought art books from his extensive collection, going through the reproductions with us and voicing enthusiastically . . . a universal appreciation for the greats of all periods and countries."[3]

OCTOBER CORNFIELDS, 1909

oil on canvas, 25" x 29"
Purchase, 1961

[1] Lawrence Campbell, *The Kennedy Galleries Are Host to the Hundredth Anniversary Exhibition of Paintings and Sculptures by 100 Artists Associated with The Art Students League of New York* (New York: The Art Students League of New York, 1975), 16.
[2] See Judy L. Larson's biography of Tucker in Peter Morrin, et al., *The Advent of Modernism: Post-Impressionism and North American Art, 1900-1918* (Atlanta, Georgia: High Museum of Art, 1986), 171.
[3] Campbell, *Hundredth Anniversary*, 23.

John F. Carlson

b. 1874 Kolsebro, Sweden
d. 1945 New York City

Although Carlson's record of study at the League is missing, he is said to have won a scholarship to study there in 1902, and to have worked primarily in the classes of Frank Vincent DuMond and Birge Harrison.[1] Carlson continued for at least four more years, winning a fellowship to the Byrdcliffe summer school in Woodstock, New York at the League's 1904 annual concours.[2] *The Pink Kimono* was painted in Augustus Vincent Tack's portrait class in 1906, and reproduced in the League's catalogue the following year. Although Carlson was clearly successful at figure painting, Harrison became his mentor, and as Carlson matured, he turned exclusively to landscape.

When the League sought a new location for the 1906 summer session, Carlson suggested Woodstock, and thus began a long association with the area. He began assisting Birge Harrison there in 1909, and became director of the summer school in 1911. With the presence of modernist artists like Andrew Dasburg and Henry Lee McFee, however, all was not harmonious within the growing artistic community. In 1918, League students petitioned for an out-door figure class that summer. Carlson felt it should be limited to those with previous training in figure painting, but was overruled, and he resigned. In 1922, when the League temporarily ended classes in Woodstock, Carlson returned there to found his own school, which operated until 1938.

THE PINK KIMONO, ca. 1906

oil on canvas, 31¼" x 24"
Scholarship Prize, Augustus Vincent Tack Portrait Class

[1] *John F. Carlson, N.A. 1874-1945* (Boston: Vose Galleries, 1978 & 1980).
[2] Karal Ann Marling, *Woodstock: An American Art Colony, 1902-1977* (Poughkeepsie, N.Y.: Vassar College Art Gallery, 1977), unpaged.

Dimitri Romanovsky

b. ca. 1886 Russia
d. 1971 New York City

Dimitri Romanovsky studied with George Bridgman and Frank Vincent DuMond at the League, but the exact dates are not known. In 1906 he was awarded a scholarship for his painting *Nude Study* in DuMond's life class. He also studied with Robert Henri and William Merritt Chase, possibly at the New York School of Art, and adopted their bravura brushwork in his own paintings. He won early success at the National Academy of Design's annual exhibitions, reportedly at the age of nineteen. Romanovsky later joined the League's staff and taught portrait painting and antique drawing from 1914 to 1917, 1925-26, and during the summers of 1925 and 1929. He was best known for his portraits, nudes and decorative flower studies.[1]

[1] See "Romanovsky Wins Popular Prize" *Art News* 30 (November 28, 1931), 26; "Dimitri Romanovsky" New York *Times*, September 28, 1971, 42; and "The Hudson Valley Art Association's Annual Exhibition with Special Tribute to Dimitri Romanovsky," (Hastings-on-Hudson, N.Y., 1970).

NUDE STUDY, 1906

oil on canvas, 20″ x 12½″
Scholarship Prize, Frank Vincent DuMond Life Class

John Sloan

b. 1871 Lock Haven, Pennsylvania
d. 1951 Hanover, New Hampshire

In 1904 John Sloan left Philadelphia for New York City, where he began painting and making etchings depicting the life of the city. One of these etchings, *Connoisseurs of Prints*, was described by Sloan as "the first of my New York life plates. It shows an exhibition of prints that were to be auctioned at the old American Art Galleries on 23rd Street."[1] Sloan had taught himself the etching process with the help of manuals on the subject by R. S. Chattock and P. G. Hamerton. Robert Henri, Sloan's friend and mentor, particularly admired this print, and praised Sloan's etchings in general "because they were made with sympathy for and understanding of life."[2] During the time that Sloan served as editor of *The Masses*, he tried to sell the New York life series as a group package with a subscription to the publication, but had no success.

Nothing is known about the sitter in Sloan's painting *Mr. Eisenhauer*, and it is doubtful that this was a commissioned portrait. It is more likely that Mr. Eisenhauer was an ordinary person whose personality or appearance appealed to the artist. Sloan and his circle deliberately avoided the fashionable side of New York, earning them the title of the "Ash Can School," and Sloan especially eschewed anything smacking of society portraiture.

Sloan taught at the League from 1916 to 1924 and from 1926 to 1930, and served as president 1930-32. He returned to teach in 1935 and remained until 1938. "If I am useful as a teacher," Sloan explained, "it is because I have dug into my own work. Teaching lashes me into a state of consciousness; I find myself trying to prove in my work some of the things I dig out of my sub-conscious to pass on to others."[3]

CONNOISSEURS OF PRINTS, 1905

etching, 9⅝" x 12½"
Provenance unknown

MR. EISENHAUER, 1913

oil on canvas, 23½" x 19¼"
Gift of the John Sloan Memorial Foundation

[1] Peter Morse, *John Sloan's Prints: A Catalogue Raisonné of the Etchings, Lithography, and Posters* (New Haven and London: Yale University Press, 1969).
[2] Ibid.
[3] Lawrence Campbell, *The Kennedy Galleries Are Host to the Hundredth Anniversary Exhibition of Paintings and Sculptures by 100 Artists Associated with The Art Students League of New York* (New York: The Art Students League of New York, 1975), 210.

MR. EISENHAUER

Sidney Dickinson

b. 1890 Wallingford, Connecticut
d. 1980 Windsor, Vermont

Sidney Dickinson studied at the League during the 1910-11 season with George Bridgman, Frank Vincent DuMond and William Merritt Chase. "I was a good student," he later recalled with pride. "I won a General Scholarship in Life Drawing, first medal in Antique Drawing, and two mentions in Still Life."[1] One of these "mentions" was for *Still Life*, painted in Chase's class, which Dickinson attended from November 1910 to April 1911.

Dickinson went on to specialize in figures and portraits, painting many well-known artistic and society figures. Throughout much of his career he also taught—at the National Academy of Design, the New School, and the League, where he was known as "Tin Can Dickinson" because of his use of a tin can to demonstrate what happens when the figure bends.[2] Dickinson also advocated studying from the antique, and claimed he benefited greatly from it himself: "I still believe it is the most logical way to train the eye in accuracy. And from the anatomical point of view, one can often learn more from the cast than from the living model."[3] Dickinson taught a total of twenty-three seasons at the League, starting in 1919-20, and continuing from 1949 until 1972, with short breaks. He also taught during the summer sessions of 1943, 1944, 1966, and 1968-72.

STILL LIFE, 1910

oil on canvas, 16" x 20"
Scholarship Prize, William Merritt Chase Still Life Cla

[1] *Art Students League News* 3, no. 15 (October 15, 1950).
[2] Ibid.
[3] Ibid.; see Dickinson's biography in Dorothy W. Phillips, *A Catalogue of the Collection of American Paintings in The Corcoran Gallery of Art, Volume II* (Washington, D.C.: The Corcoran Gallery of Art, 1973), 131.

Arnold Blanch

b. 1896 Mantorville, Minnesota
d. 1968 Kingston, New York

In 1916 Arnold Blanch came to New York City with a scholarship to the League, where for two years he studied primarily with F. Luis Mora, Frank Vincent DuMond, Robert Henri and John Sloan. He found the latter two instructors "enormously stimulating."[1] Returning to the League in 1920, Blanch worked mostly with Kenneth Hayes Miller and his early "hero," Boardman Robinson.[2] Blanch's concern with solid, monumental form in the early part of his career can be seen in *Circus Girl*. Later, during the Depression, his style became more painterly, and his subject matter changed to reflect social concerns. In the early 1940s he turned to more cheerful subjects, painting whimsical landscapes.

Blanch taught at the League from 1935 to '39, and at its summer school in Woodstock from 1947 to '68. An "avowed enemy of all rule and formula," Blanch preferred the short summer schedule, to avoid "repeating what becomes a bore."[3] In an effort to escape routine, he was said to have his students "work with unorthodox tools, such as scissors and paper." "My attitude is to encourage in all my students a basic creative initiative rather than a skill," he explained in 1950.[4]

[1] Arnold Blanch, *Arnold Blanch* (New York: American Artists Group, 1946), unpaged.
[2] Arnold Blanch, "Boardman Robinson the Teacher," in Albert Christ-Janer, *Boardman Robinson* (Chicago: University of Chicago Press, 1946), 73.
[3] "Artist Out of the Ivory Tower," *Art Students League News* 3, no. 12 (July 1, 1950); Blanch, *Arnold Blanch*.
[4] "Artist Out of the Ivory Tower."

CIRCUS GIRL

oil on canvas, 49 ¾" x 29 ½"
Purchase, 1962

Charles Courtney Curran

b. 1861 Hartford, Kentucky
d. 1942 New York City

After preliminary art studies in Cincinnati, Charles Courtney Curran came to New York and reportedly studied at the League, although no record exists there.[1] In 1888 he went to Paris and worked at the Académie Julian. He later returned to New York and established a reputation for painting charming studies of women and children in outdoor settings, often using flowers as a major element of the composition. These themes, as typified in his painting *Woman Reading*, relate to those of the French Impressionists. However, unlike the Impressionists, Curran painted in a crisp, sometimes tight style, using light to define form rather than dissolve it.[2] Curran taught at the League for two seasons in 1901-03. He later became a member of the artists' colony at Cragsmoor, New York, and wrote a column for the magazine *Palette and Bench*, in which his ideas on painting can be found.

WOMAN READING, ca. 1901

oil on canvas, 9" x 12¼"
Gift of the artist

[1] Homer St. Gaudens, "Charles Courtney Curran," *The Critic* 48, no. 1 (January 1906), 39.
[2] See William H. Gerdts, *American Impressionism* (New York: Abbeville Press, 1985), 230.

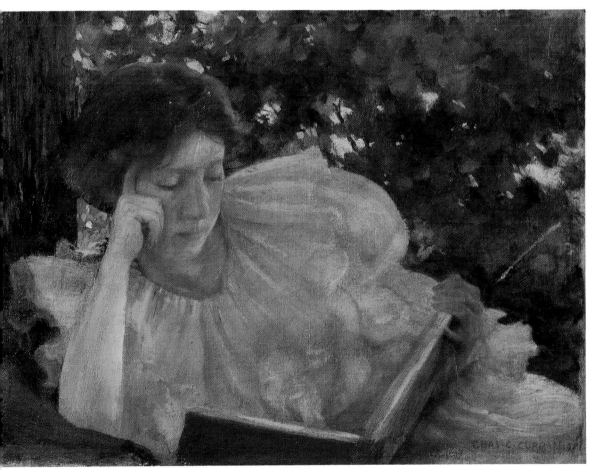

Woman Reading

Eugene Speicher

b. 1883 Buffalo, New York
d. 1962 Woodstock, New York

While studying at the Albright Art School in Buffalo, Eugene Speicher was awarded a scholarship to the League for 1907 and part of 1908, where he studied with William Merritt Chase and Frank Vincent DuMond. "I was fortunate to come under Frank DuMond's teaching and influence," Speicher later remembered. "What success I have since had, is largely due to his wise counsel and sympathetic understanding."[1]

Fellow student Georgia O'Keeffe related how the handsome Speicher frequently asked to paint her portrait, and how she had just as regularly refused him, until one morning in 1908: "As I climbed to the top floor for the Life Class, there he sat with his fresh linen smock, blocking the whole stairway and threatening that he would not let me pass unless I promised to pose for him." O'Keeffe insisted on going on to her class, but then found the model "repulsive" and decided to give in. She recalled, "He worked very quickly and the portrait was soon finished – probably because he had it so clear in his mind when he started."[2] O'Keeffe appears almost coquettish in this painting, compared to the severe image she projects in the photographic studies Alfred Stieglitz later made of her. One biographer explained that O'Keeffe's uncharacteristic curls were the result of the loss of her hair after contracting typhoid the year before she enrolled at the League.[3] Speicher's portrait won him the Kelly Prize in Chase's portrait class. He went on to a successful career as a portrait and figure painter, becoming more interested in form and pictorial construction as his style evolved. He taught at the League from 1908 to 1913 and during the 1919-20 season.

PORTRAIT OF GEORGIA O'KEEFFE, 1908

oil on canvas, 21½″ x 18″
Scholarship Prize, William Merritt Chase
Portrait Class(?), 1908

[1] *A Memorial Exhibition of Paintings by Frank Vincent DuMond, N.A. sponsored by the Art Students League of N.Y. in the Galleries of the National Academy of Design* (New York: The Art Students League of New York, 1952), 3.

[2] Georgia O'Keeffe, *Georgia O'Keeffe* (New York: The Viking Press, 1976), unpaged.

[3] Jan Garden Castro, *The Art and Life of Georgia O'Keeffe* (New York: Crown Publishers, 1985), 8.

PORTRAIT OF GEORGIA O'KEEFFE

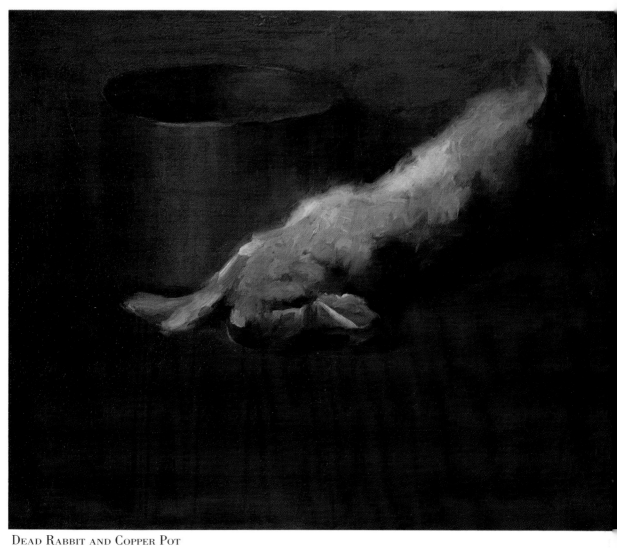

Dead Rabbit and Copper Pot

Georgia O'Keeffe

b. 1887 Sun Prairie, Wisconsin
d. 1986 Santa Fe, New Mexico

Georgia O'Keeffe's artistic talent was noticed by a high-school teacher, Elizabeth May Willis, who had studied at the League. She persuaded O'Keeffe's mother to allow Georgia to live with relatives in Chicago and study at the Art Institute in 1905-06. O'Keeffe came to New York at the age of twenty to attend the League in 1907-08. She took life classes with F. Luis Mora, and studied still life with William Merritt Chase for five months. She also worked for one month in Kenyon Cox's anatomy class.

"Patsy," as she was known at the League, was a serious student known to be meticulous with her materials. The subject and handling of her painting *Dead Rabbit and Copper Pot* earned the approval of her teacher Chase, who awarded her a scholarship for the League's summer school at Lake George. O'Keeffe, in turn, considered Chase "a very good teacher," and enjoyed his still life class immensely. She later wrote: "I loved the color in the brass and copper pots and pans, peppers, onions and other things we painted for him. . . . To interest him, the paintings had to be alive with paint and a kind of dash and 'go' that kept us looking for something lively."[1] She credited Chase with encouraging "individuality," and felt that he "gave a sense of style and freedom to his students" – a quality the already independent-minded O'Keeffe would have valued.[2]

[1] Georgia O'Keeffe, *Georgia O'Keeffe* (New York: The Viking Press, 1976), unpaged; see also Katherine Hoffman, *An Enduring Spirit: The Art of Georgia O'Keeffe* (Metuchen, N.J.: The Scarecrow Press, 1984), and Jan Garden Castro, *The Art and Life of Georgia O'Keeffe* (New York: Crown Publishers, 1985).
[2] Georgia O'Keeffe, letter to Ronald Pisano, September 18, 1972.

DEAD RABBIT AND COPPER POT, 1908

oil on canvas, 19″ x 23½″
Scholarship Prize, William Merritt Chase Still Life Class

Alexander Stirling Calder

b. 1870 Philadelphia
d. 1945 New York City

Originally, Alexander Stirling Calder was interested in a military career, then he planned on working in the theater, but he ultimately chose to study art at the Pennsylvania Academy of the Fine Arts in the late 1880s. He went on to Paris and worked at the Académie Julian and the Ecole des Beaux-Arts. Upon his return to the United States, he settled in Philadelphia, taught for a few years at the Philadelphia Museum School of Industrial Art, and worked at making portrait busts and nudes. In 1910 Calder moved to New York and taught at the National Academy of Design. By the early 'teens Calder was a nationally known sculptor: he oversaw the sculptural program at the Panama-Pacific Exposition held in San Francisco in 1915, and began to win commissions for monumental public works, which he executed in the Beaux-Arts style. Calder believed that "the public use of sculpture is its highest field and goal."[1]

Calder taught sculpture at the League from 1918 to 1922, a period that coincided with a shift in his work to a more modern, simplified style, reflecting his receptivity to new developments in art. He explained his approach in this manner: "Nature's way is to develop form from a seed, to swell, expand, and attain full growth . . . by pushing outward toward the light. This is my idea of sculpture, a building up and outward from the kernel of thought that inspires."[2]

NUDE

bronze, 34" x 9" x 9½"
Gift of Janet LeClair

[1] Nanette Calder, ed., *Thoughts of A. Stirling Calder on Art and Life* (New York: privately printed, 1947), 11.

[2] Ibid., 27-28; see also Libby W. Seaberg's biography in Tom Armstrong, et al., *200 Years of American Sculpture* (New York: David R. Godine in association with the Whitney Museum of American Art, 1976), 263.

Abraham Walkowitz

1880 Tyumen, Siberia, Russia
1965 Brooklyn, New York

The early modernist Abraham Walkowitz had a traditional training at the National Academy of Design in New York. From 1900 to 1906 he taught at the Educational Alliance and worked as a sign painter in order to save money to live and study in Europe. He spent 1906-07 in Paris, where he studied at the Académie Julian and became friendly with Max Weber. While in Paris he visited Rodin's studio, where he may have met the dancer Isadora Duncan, and where he certainly saw the drawings Rodin made of her. To Walkowitz, Duncan represented a free and modern spirit, a symbol of all that he admired. He made thousands of studies of her, not just in Paris or New York, where she performed in 1908, 1909, 1915 and 1916, but throughout his career. His drawings are simple and flowing, like the group of six represented here. In 1958 he said: "Isadora is movement. I watched her dances, and I never had her pose. I just watched the movement, that's what makes the dance—the feeling, the movement, the grace. That's what I got."[1]

Kent Smith, *Abraham Walkowitz: Figuration, 1895-1945* (Long Beach, California: Long Beach Museum of Art, 1982), 7; see also Martica Sawin, *Abraham Walkowitz, 1878-1965* (Salt Lake City, Utah: Utah Museum of Fine Arts, 1974).

SIX VIEWS OF ISADORA DUNCAN

watercolor on paper, 7″ x 2⅝″ (each)
Bequest of the Estate of Robert Philipp

Ogden Pleissner

b. 1905 Brooklyn, New York
d. 1983 London

Ogden Pleissner grew up in an artistically inclined family and drew continually from an early age. After his graduation from Brooklyn Friend's School, instead of entering Williams College as his family wished, Pleissner attended the League from 1923 to '29. He later described the League as "a wonderful place. You went there to paint or draw, and if you wanted to take instruction and learn you could, or you could just sit in the cafeteria and talk with students. Tuition was not very much."[1] Pleissner studied primarily with Frank Vincent DuMond and George Bridgman. He considered Bridgman "a very thorough teacher," and "learned a great deal from him," but was more influenced by DuMond, in whose 1926 class he won a prize for his painting *Male Nude.*[2]

After leaving the League, Pleissner painted landscapes in Brooklyn, the West, and New England. During World War II Pleissner was assigned briefly to the Aleutian Islands, where he first began painting watercolors seriously; then he served in the Air Force as a correspondent for *Life* magazine. Describing his artistic development, Pleissner stated: "At first I was influenced a great deal . . . by DuMond, but then a real change occurred when the war came along. [My work] became much broader, massive, and had a great deal more depth."[3] After the war, Pleissner worked primarily in watercolor, becoming known for his technically accomplished landscapes painted during his extensive travels, and for his sporting scenes in the tradition of his teacher, DuMond.

MALE NUDE, 1926

oil on canvas, 30″ x 18¼″
Scholarship Prize, Frank Vincent DuMond Life Class

[1] Peter Bergh, *The Art of Ogden M. Pleissner* (Boston: David R. Godine, 1984), 3.
[2] Ibid., 14.
[3] Ibid., 4.

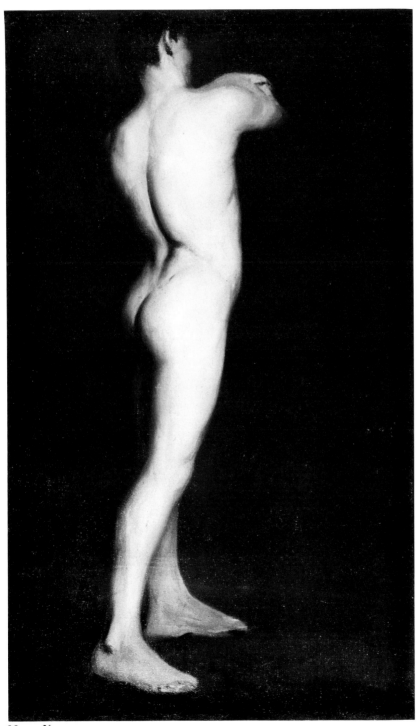

MALE NUDE

Louis Lozowick

b. 1892 Ludvinovka, Ukraine
d. 1973 South Orange, New Jersey

Louis Lozowick made his first lithograph in 1923 while visiting Berlin. Upon his return to New York City in the mid-1920s, he began using the medium frequently, finding that it suited his modernist celebration of cityscapes and industry. The first major showing of his lithographs was held in New York at the Weyhe Gallery in 1929, the same year he made *Breakfast*. The unusual perspective and the grid-like pattern in the lower left are compositional devices he often used. There are several odd elements, however, such as the "lace" band running diagonally across the picture plane and the automobile in the upper left corner. These incongruous touches suggest that Lozowick was playing with the medium, experimenting with different textures and spatial relationships.[1]

[1] See Janet Flint, *Louis Lozowick: Drawings and Lithographs* (Washington, D.C.: National Collection of Fine Arts, 1975) and Janet Flint, *The Prints of Louis Lozowick: A Catalogue Raisonné* (New York: Hudson Hills Press, 1982).

BREAKFAST, 1929

lithograph, 15¹³⁄₁₆″ x 11³⁄₈″
Bequest of the Julian Levi Estate, 1982

Breakfast

Kenneth Hayes Miller

b. 1876 Oneida, New York
d. 1952 New York City

Kenneth Hayes Miller studied at the League from 1891 to '96 with Kenyon Cox and H. Siddons Mowbray. He continued his training with William Merritt Chase at the New York School of Art, and then made the obligatory tour of European museums. He began his long teaching career in 1899, and joined the League's faculty in 1911. He taught life classes at the League until 1936, except for the 1929-30 and 1931-32 seasons. In 1944 he returned, and taught until 1951. Miller stated, "At the League, I learn as much as I teach."[1] His firm ideas about form and design and his intellectual approach to painting made him something of an icon to his students. Isabel Bishop remembered how Miller conveyed an "aura" relating to his belief that "the pursuit of the Art of Painting" was "of *absolute* importance."[2]

Miller's goal in his own art as well as in his teaching was "to bridge the gulf between old masters and moderns."[3] The shoppers portrayed in his painting *Women in the Store* are a typical theme, but his primary concern was with developing form: "I am not interested in subject matter of any particular kind. I touch contemporary life in themes relating to shopping, but what has absorbed me has always been simply the *body* . . . it is the body, the very envelope of our conscious being, which seems to me the first reality."[4]

WOMEN IN THE STORE, 1937

oil on canvas, 19" x 24"
Purchase, 1949

[1] *Art Students League News* 1, no. 2 (May 15, 1948).

[2] Sheldon Reich, *Isabel Bishop* (Tucson: The University of Arizona Museum of Art, 1974), 27.

[3] *Art Students League News.*

[4] Grace Pagano, *Contemporary American Painting* (New York: Duell, Sloan and Pearce, 1945), unpaged; see Lincoln Rothschild, *To Keep Art Alive: The Effort of Kenneth Hayes Miller, American Painter (1876-1952)* (Philadelphia: The Art Alliance, 1974).

WOMEN IN THE STORE

Katherine Schmidt

b. 1898 Xenia, Ohio
d. 1978 Sarasota, Florida

As a girl of thirteen, Katherine Schmidt attended the League's Saturday classes for children, where she practiced drawing from antique casts. After her graduation from high school in 1916, she enrolled at the League and took life classes with F. Luis Mora. She continued with Mora and studied briefly with John Sloan and George Bridgman, but it was Kenneth Hayes Miller who was to exert the most influence on her work. "My infinite debt is to Miller," she later stated.[1] In 1919 Schmidt married fellow student Yasuo Kuniyoshi, and since they had very little money, she ran the League's lunchroom for a time.

Schmidt's paintings of the 1920s and '30s are primarily figures, landscapes and still life, all executed with a strict attention to form derived from Miller. In the mid to late 1930s she and many of her artist friends made a number of paintings and drawings of victims of the Depression, in particular a man named Walter Broe, who may have served as the model for her drawing *Awkward Sleep*. Schmidt explained: "He interested me not only for the special qualities he had as an individual but for the symbolic character which to me he represented as well. Ill-used by life, Walter needed warmth, and he wanted something in his life which would give value."[2]

AWKWARD SLEEP, 1935

pencil on paper, 11⅛" x 7⅝"
Bequest of the Estate of Julian Levi, 1982

[1] Lloyd Goodrich, *The Katherine Schmidt Shubert Bequest and a Selective View of Her Art* (New York: Whitney Museum of American Art, 1982), 6.
[2] Ibid., 14.

Peggy Bacon

b. 1895 Ridgefield, Connecticut
d. 1987 Kennebunk, Maine

Peggy Bacon considered herself "as much a product of the League as it is possible to be."[1] Her parents, Charles Roswell Bacon and Elizabeth Chase, met at the League in 1890. Thus their daughter grew up in an artistic household, and began studying at the League herself in the fall of 1915. Over the next four and half years, Bacon took life classes with Kenneth Hayes Miller and John Sloan and studied portraiture with George Bellows. She also studied briefly with George Bridgman and Max Weber. Bacon found Miller's criticisms too Freudian, and did not share Bellows's enthusiasm for the theories of Maratta and Jay Hambidge. Her favorite and most influential teacher was Sloan, with whom she also studied composition. In 1918, Bacon met Alexander Brook in the League's lunchroom. They attended the 1919 summer session in Woodstock (where Bacon worked with Andrew Dasburg), and they were married in 1920.

Although Bacon studied painting at the League, it was her satirical drypoints that first won her recognition. Her independent experimentation with printmaking began in 1917 at the League, and she made several prints depicting activities there. As in the drypoint *Allure*, Bacon often included a cat in her work, and they became a trademark. Though the degree of satire lessened in her later work, Bacon's amused observation of human and animal behavior is a consistent theme.[2]

Bacon later returned to the League to teach life classes during the 1935-36 season, and again from 1948 through February 1952.

[1] *Art Students League News* 2, no. 13 (September 1, 1949).
[2] See Roberta Tarbell, *Peggy Bacon: Personalities and Places* (Washington, D.C.: National Collection of Fine Arts, Smithsonian Institution Press, 1975).

Allure, 1932

drypoint, 8¹¹/₁₆" x 11⅛"
Purchased from the artist, ca. 1975

Robert Brackman

b. 1898 Odessa, Russia
d. 1980 New London, Connecticut

Robert Brackman took life classes at the League with Edward Dufner in 1915-16. He continued his studies at the National Academy of Design and at the Ferrer School in San Francisco. Later, he taught summer classes at the League in 1931, 1932 and 1934-38, and joined the faculty full time in 1934. With the exception of a few short breaks, Brackman taught life, portrait and still-life classes until 1975. He also opened his own summer school in Noank, Connecticut in 1938. Brackman thought of painting as a craft, and insisted that a student be "an excellent artisan," in command of "construction and draughtsmanship."[1] He explained his approach to painting and teaching this way: "You don't teach portrait painting, you just teach painting. Not until the student has learned to seize the beauty of a picture as a whole has he learned anything about painting. No single item or single idea should dominate. The entire picture should dominate – nothing else."[2]

Brackman's own paintings were thoughtfully designed and painted in calm, carefully modulated colors with rich accents. His portraits and monumental figure groups have the same deliberate arrangement of his still lifes. Brackman was married to Rochelle Post for a time; she served as his model for *Rochelle in White* as well as many other paintings. After their divorce, she married artist friend Robert Philipp in 1935, and often served as his model as well.[3]

ROCHELLE IN WHITE

oil on canvas, 72" x 36"
Gift of the Robert Philipp Estate, 1981

[1] Kenneth Bates, *Brackman: His Art and Teaching* (Madison, Connecticut: Madison Art Gallery Publishing, 1973), 46; *The Art Students League of New York Catalogue for 1936-37*, 28.

[2] *Art Students League News* 1, no. 6 (October 15, 1948).

[3] Elizabeth Wylie, *Robert Philipp: Artist and Teacher* (New York: Grand Central Art Galleries in association with The Art Students League of New York, 1985), 13.

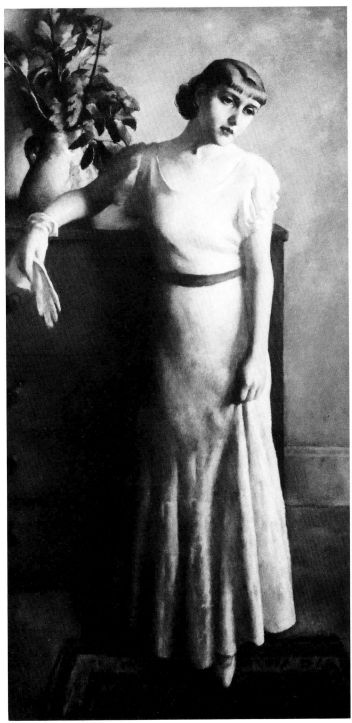

ROCHELLE IN WHITE

Dorothy Dehner

b. 1901 Cleveland, Ohio

Dorothy Dehner first began to draw seriously in 1925 while traveling in Europe. She was especially attracted to the Cubist paintings and sculptures she saw in Paris. She enrolled at the League in the fall of 1925 intending to study sculpture, but instead chose to improve her drawing skills by working from casts in Kimon Nicolaides's class. The 1926-27 season under Kenneth Hayes Miller was uninspiring, but Dehner blossomed in 1930-31 with Jan Matulka's guidance. She later wrote: "Matulka gave us that extra feeling of confidence in ourselves which acknowledged our serious intent to become professional artists."[1]

It was in the late 1920s that Dehner and her new husband, fellow student David Smith (who later became one of America's most acclaimed sculptors), became friendly with Weber Furlong, administrative head of the League. Furlong and her husband Thomas were part of a sophisticated artistic circle, and through them Dehner met many avant-garde painters. She painted *Portrait of Weber Furlong* during the last year of her studies with Matulka at the League. Her initial attraction to Cubism and sculpture is evident in the architectonic treatment of her subject. A few years later, she turned to a more naturalistic style, and in the 1950s acted on her early interest and took up sculpture.[2]

PORTRAIT OF WEBER FURLONG
(WILHELMINA WEBER FURLONG), 1931

oil on canvas, 28½" x 22"
Gift of the artist, 1975

[1] Dorothy Dehner, "Memories of Jan Matulka," in Paterson Sims, et. al., *Jan Matulka, 1890-1972* (Washington, D.C.: Smithsonian Institution Press, 1980), 77.

[2] See Joan Marter and Judith McCandless, *Dorothy Dehner/David Smith: Their Decades of Search and Fulfillment* (New Brunswick, N.J.: The Jane Voorhees Zimmerli Art Museum, Rutgers University, 1983).

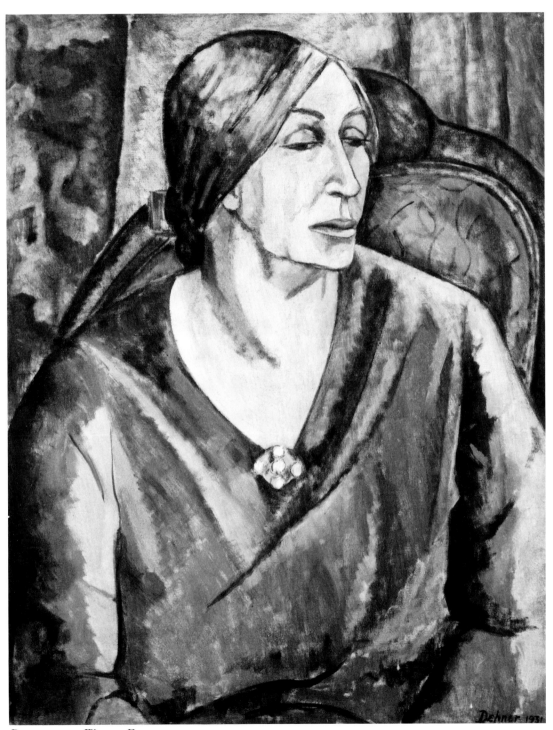

Portrait of Weber Furlong

Gifford Beal

b. 1879 New York City
d. 1956 New York City

Gifford Beal is generally credited with studying under Henry Ward Ranger at the League, but only three months' attendance in Frank Vincent DuMond's life class in 1903 have been recorded. Beal himself wrote that he attended DuMond's classes "for two or three years," and that "his demonstrations before the classes were really remarkable and never to be forgotten."[1] Beal later became an active member of the League, serving as President in 1916-17, 1918-19, and 1920-30. He also taught drawing, painting and composition in 1931-32. Throughout his career, Beal favored certain motifs, among them circus scenes and New York's Central Park, leading many contemporary critics to describe his work as particularly "American." In the mid-1920s he painted a series depicting fishermen at work, of which *Net Wagon* is a well-known example. Vigorous brushwork and rhythmic, expressive line are used effectively in these compositions, which incorporate figures silhouetted dramatically against a low horizon.[2]

[1] *A Memorial Exhibition of Paintings by Frank Vincent DuMond, N.A. Sponsored by the Art Students League of N.Y. in the Galleries of the National Academy of Design* (New York: The Art Students League of New York, 1952), 5.
[2] See *Gifford Beal, 1879-1956: A Centennial Exhibition* (New York: Kraushaar Galleries, 1979) and *Gifford Beal: Paintings and Watercolors* (Washington, D.C.: The Phillips Collection, 1971).

NET WAGON, 1926

oil on canvas, 36" x 58"
Purchase, 1950

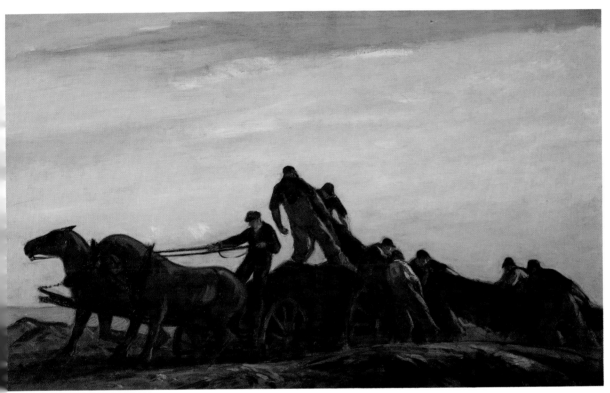

NET WAGON

Vaclav Vytlacil

b. 1892 New York City
d. 1984 New York City

After studying at the Art Institute of Chicago, Vaclav Vytlacil came to the League in 1913 or 1914 and studied with John D. Johannsen until 1916, in part with a scholarship. From 1916 to 1921 he taught at the Minneapolis School of Art; then he embarked for Europe. He settled in Munich, studied at the Royal Academy, and then became one of the first American students at Hans Hofmann's school there. In 1928 he returned to the League and gave a series of twelve lectures, the first serious attempt to introduce European modernism into the curriculum. Shortly afterwards, Vytlacil returned to Europe with the idea of inviting Hans Hofmann to teach at the League (which he later did during the 1932-33 season). Vytlacil's early painting *Still Life with Fruit and Guitar* shows the influence of the cubists. He later experimented further with abstraction, and finally developed a more painterly abstract style with figurative references.[1]

In 1935 Vytlacil returned to New York and began teaching at the League. He remained until 1942, and taught again from 1945 to '61, 1964 to '73, and 1974 to '81. Vytlacil preferred that his students "have damn good academic training" before entering his class, because "only after mastering the forms of nature . . . can students consider intelligently the problems of form and space—of space in its various manifestations, including color and light."[2]

STILL LIFE, 1930

oil on canvas, 40¼" x 33"
Purchase, 1983

[1] See Lawrence Campbell, *Vaclav Vytlacil: Paintings and Constructions from 1930* (Montclair, N.J.: Montclair Art Museum, 1975).
[2] *Art Students League News* 2, no. 4 (March 1, 1949).

Walter Quirt

. 1902 Iron River, Michigan
. 1968 Minneapolis, Minnesota (?)

Walter Quirt received his only formal art training at
the Layton School of Art in Milwaukee, which he at-
tended from 1921 to '23. He taught part-time there
from 1924 to '28, before moving to New York City in
1929. Quirt's circle in New York included Abraham
Rattner, Max Weber, Stuart Davis, Marsden Hartley
and Joseph Stella. Of his friends he said: "They did
something better than influence me. They gave me a
philosophy."[1]

Quirt did not take up oil painting until 1933 because
he couldn't afford the materials. *Surreal Landscape*
was done in the mid to late 1930s when Quirt was
painting small works in a surrealistic style. As con-
temporary critics pointed out, Quirt's style resembled
Salvador Dali's, but rather than expressing an inner
experience, Quirt's work generally dealt with issues
of the day such as race and labor relations.[2] Later,
Quirt worked in increasingly painterly abstract styles,
but his work never lost a representational reference.

SURREAL LANDSCAPE, ca. 1935-40

oil on canvas, 10½" x 15"
Provenance unknown

Robert M. Coates, *Walter Quirt* (New York: The American
Federation of Arts, 1960), 7.
"Quirt – American Surrealist," *Art Digest* 10 (March 1,
1936), 16; "Walter Quirt – Socialized Surrealist," *American
Magazine of Art* 29 (April 1936), 260.

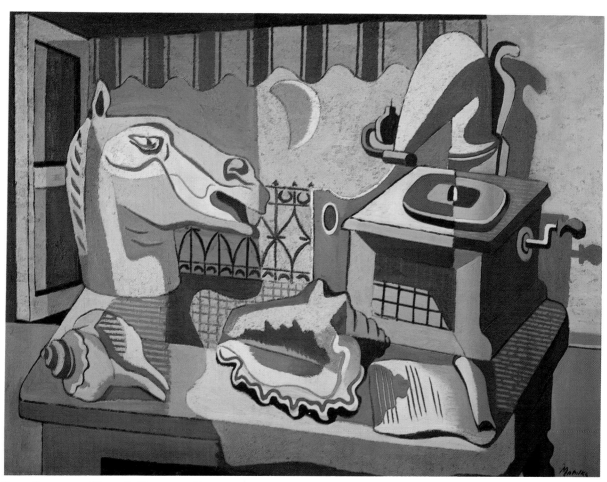

STILL LIFE WITH HORSE'S HEAD AND PHONOGRAPH

Jan Matulka

b. 1890 Vlachova Brezi, Czechoslovakia
d. 1972 Queens, New York

It is thought that Matulka sat in on the classes of Kenneth Hayes Miller and George Luks at the League during the 1920s, having already studied at the National Academy of Design (1908-17). He had been exposed to modernist ideas in the late 'teens through his friends James Daugherty and Jay Van Everen, and in Paris in the early 1920s. Matulka officially enrolled in Eugene Fitsch's etching class at the League as a scholarship student in the spring of 1925, but he had probably worked informally with Fitsch as early as 1923. It was Fitsch who introduced Matulka to lithography, which would become an important medium for him.

In 1928 Matulka learned of a position at the League through his friend Vaclav Vytlacil, and Max Weber, another friend, encouraged him to take it. He taught drawing from 1929 to 1931, often using rapid sketches to get his ideas across. Enlarged photographs of two Picasso paintings and an African head were displayed in his class. One student, Dorothy Dehner, recalled that Matulka was "a very avant-garde figure. He was bold in his concepts, unique in his palette, and unshakable in his convictions."[1] Insufficient enrollment and opposition led by Kenneth Hayes Miller led to the cancellation of his class, but many students continued to study with him privately for a time.

Matulka recommended that his students use wood shavings, coffee grounds, sand or palette scrapings to add surface interest to their paintings. This interest in texture can be seen in *Still Life with Horse's Head and Phonograph*. The painting is one of a series Matulka painted around 1930, most of which include the phonograph and shells. These paintings are considered some of the strongest of his career.

1 Dorothy Dehner, "Memories of Jan Matulka," in Paterson Sims, et al., *Jan Matulka, 1890-1972* (Washington, D.C.: Smithsonian Institution Press, 1980), 78.

STILL LIFE WITH HORSE'S HEAD AND PHONOGRAPH, ca. 1930

oil on canvas, 30" x 40"
Purchase, 1968

William Zorach

b. 1887 Euberick, Russia
d. 1966 Bath, Maine

William Zorach grew up in Cleveland, where he studied drawing and painting and worked as a commercial lithographer. He continued his studies in New York, spending one month with George Bridgman at the League in 1907, which was all he could afford, according to his memoir, *Art Is My Life*. He studied at the National Academy of Design from 1908 to 1910. Zorach then moved to France for two years, where he studied at La Palette, John Duncan Fergusson's progressive school in Paris. There he met Marguerite Thompson, whom he married when he returned to New York in 1912. For the next several years the Zorachs painted similar works in a Fauvist manner.

William Zorach made his first sculpture, a wooden relief panel, in the summer of 1917, and in 1922 he turned to sculpture almost exclusively, although he never gave up painting in watercolor. He was an early and vocal proponent of direct carving in wood and stone. Zorach carved a portrait of *Hilda* in a yellowish Italian marble and made *Torso* in Labrador granite, and also cast both pieces in bronze.[1] Their stylized simplicity and calm solidity are hallmarks of Zorach's style.

Zorach taught at the League from 1929 to 1959. He recalled in his autobiography, "This meant a great deal to me. It gave me status and it meant a dependable income of two thousand a year. . . . I took the students very seriously and gave them everything I had." Zorach called his basement studio at the League "wonderful training in how to work under the most adverse conditions."[2]

HILDA, 1931

bronze, 13″ x 8½″ x 10″
Purchase, 1950

BRONZE TORSO, 1932

bronze, 32″ x 11″ x 15″
Gift of Tessim Zorach, 1976

[1] See Paul S. Wingert, *The Sculpture of William Zorach* (New York and Chicago: Pitman Publishing, 1938).
[2] William Zorach, *Art Is My Life* (Cleveland and New York: World Publishing, 1967), 74; 126.

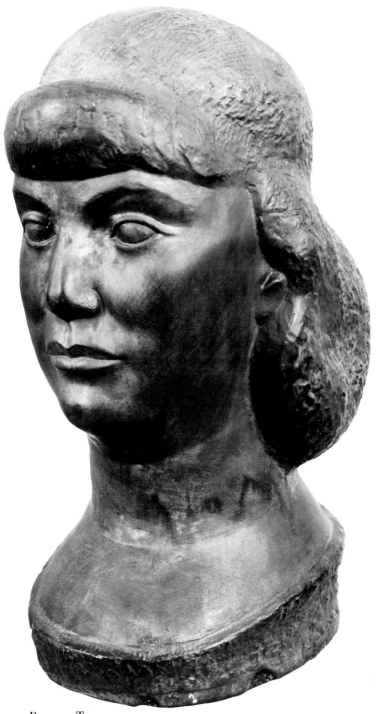

BRONZE TORSO

Marguerite Zorach

b. 1887 Santa Rosa, California
d. 1968 Brooklyn, New York

In 1908 Marguerite Thompson left an intellectual but relatively sheltered home in California for Paris, where she immediately immersed herself in the most progressive trends in painting. She studied briefly at the conservative Ecole de la Grande Chaumière, and then enrolled at John Duncan Fergusson's school, La Palette. There she met William Zorach, whom she later married. Thompson was deeply impressed by the work of Picasso and the French Fauves, and she developed her own bold style. Using simplified form, strong contour and intense color, she painted subjects inspired by her deep love of nature.

Thompson returned to California, then moved to New York City in 1912, where she and her new husband William Zorach became active in an avant-garde circle of artists and writers. They both taught at the Modern Art School in New York, and Marguerite wrote articles for newspapers. She exhibited in the Armory Show in 1913, was selected for the Forum Exhibition in 1916, and served as the first president of the New York Society of Women Artists, formed in 1925. After the birth of her children in the late 'teens, she began creating highly inventive designs in wool. Throughout her career, she made many pencil portraits of friends and associates, like this one of sculptor Reuben Nakian. Described as "the most retreating of all humans," Marguerite Zorach's important body of work was largely overshadowed by her husband's reputation.[1]

PORTRAIT OF REUBEN NAKIAN

pencil on paper, 20⅝" x 15¼"
Purchase

[1] Marya Mannes, "The Embroideries of Marguerite Zorach," *International Studio* 95, no. 394 (March 1930), 29; see Roberta K. Tarbell, *Marguerite Zorach: The Early Years, 1908-1920* (Washington, D.C.: National Collection of Fine Arts, Smithsonian Institution Press, 1974) and Joan M. Marter, "Three Women Artists Married to Early Modernists: Sonia Delaunay-Terk, Sophie Taüber Arp and Marguerite Thompson Zorach," *Arts Magazine* 54, no. 1 (September 1979), 89-95.

Burgoyne Diller

b. 1906 New York City
d. 1965 New York City

In 1928 Burgoyne Diller came to the League with a scholarship, and over the next five years he studied with a variety of artists, most importantly Jan Matulka, George Grosz and Hans Hofmann. He also took printmaking courses with Charles Locke, Harry Wickey and George Picken; and during the 1929-30 season, he ran the League's store. Diller was awarded a scholarship prize for *Still Life*, painted in Hofmann's class in 1932, although it shows more the influence of Matulka, with whom he studied the longest. However, Hofmann's theories ultimately had the most impact on the young artist, who also admired the work of the Russian constructivists and the de Stijl group.

In his mature work Diller embraced abstraction completely, finally adopting a style closely related to the gridwork paintings of Piet Mondrian. Diller and artists with similar goals formed the group American Abstract Artists in the mid-1930s as an attempt to promote abstract art by artists in this country. Despite their efforts, they continued to be overshadowed by the prevailing taste for American scene painting and social realism, and for the work of European abstractionists.

In his capacity as head of the mural division of the WPA Federal Art Project from 1935 to 1942, Diller awarded projects to fellow abstract painters Stuart Davis, Arshile Gorky and Fernand Léger. Diller later taught at Brooklyn College from 1946 until his death in 1965.[1]

[1] See *Burgoyne Diller: Paintings, Sculptures, Drawings* (Minneapolis: Walker Art Center, 1971).

STILL LIFE, 1932

oil on canvas, 20¼" x 16"
Scholarship Prize, Hans Hofmann Class

Morris Kantor

b. 1896 Minsk, Russia
d. 1974 New York City

Morris Kantor came to this country when he was about thirteen years old. Despite opposition from relatives, he began his art studies with Robert Henri and Homer Boss at the Independent School in 1916 with the intention of becoming a cartoonist. Instead, Boss encouraged him to paint. Kantor experimented first with abstraction, then developed a concern with balance and order. He resumed his studies with Boss at the League in 1923. Kantor continued to absorb influences from a variety of sources, but felt that his work did not "click" until after a year-long trip to France in 1927 made possible by his friend Walter Pach. In the fall of 1928 he began a group of paintings using interiors with still lifes and views to the outside. *Still Life* is part of this series, as over the next few years Kantor played with "indoor and outdoor together to create the atmosphere of the inside of the house and its relation to the outside environment."[1] Kantor's work went through different phases throughout his career, though after the 1940s these changes were within an abstract framework. "Each painting should stand by itself, not only as to subject matter, but also technically," Kantor explained in 1942. "Variety is the basis of all living force."[2]

Kantor taught life classes at the League full time from 1936 to 1972, and summer classes in 1934, 1935, and 1954-57. He was a gentle, sympathetic man, who preferred mature students to beginners, because, as he explained, "to teach the fundamentals takes a pedagogue, and I'm not a pedagogue. I'm a painter."[3] True to his flexible style, Kantor varied his approach depending on the student and the painting.

STILL LIFE, 1932

oil on canvas, 24¾" x 19½"
Purchase

[1] Monroe Wheeler, ed., *Painters and Sculptors of Modern America* (New York: Thomas Y. Crowell, 1942), 45.
[2] Ibid.
[3] *Art Students League News* 2, no. 3 (February 1, 1949).

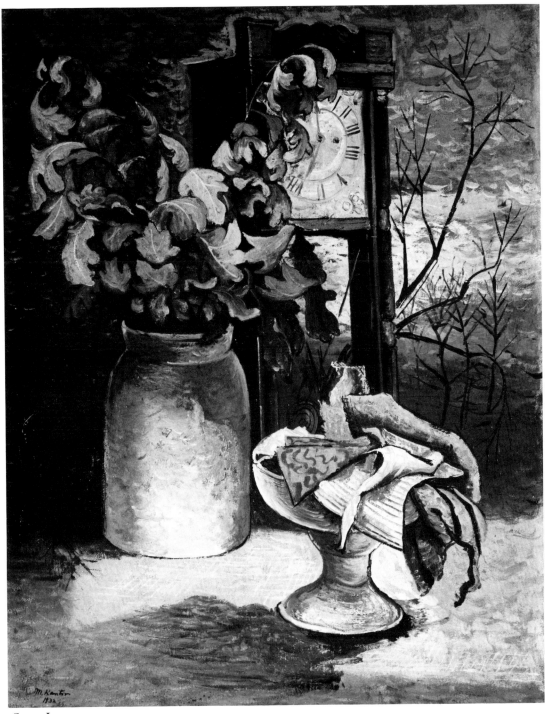

Still Life

Ralston Crawford

b. 1906 Saint Catherines, Ontario
d. 1975 Houston, Texas

After a brief period at the Otis Art Institute in Los Angeles in 1927, Ralston Crawford spent the following three and a half years at the Pennsylvania Academy of the Fine Arts under Henry McCarter and Hugh Breckenridge. While in Philadelphia, Crawford attended lectures given by Dr. Albert Barnes, whose formal analysis of paintings from different periods helped shape the young artist's approach. He was especially impressed by a Cézanne that Barnes owned.

Flour Mill #2 was painted just as Crawford developed a mature style, and is typical of the work for which he received the most acclaim. This painting is part of a series he made of industrial subjects while living in Exton, Pennsylvania from 1935 to '37. These works are made up of sharp geometric forms defined with smooth planes of neutral colors, accented with areas of bright color. The compositions are cropped and abstracted, but the subject is always recognizable. Crawford explained the "severity" of his work: "I am in many respects an incurable romantic. . . . I am long on feeling, and a lot of discipline – or steering of that feeling – is necessary."[1]

[1] Barbara Haskell, *Ralston Crawford* (New York: Whitney Museum of American Art, 1985).

FLOUR MILL #2, 1937

oil on canvas, 22" x 28"
Gift of Muriel Hillman, 1968

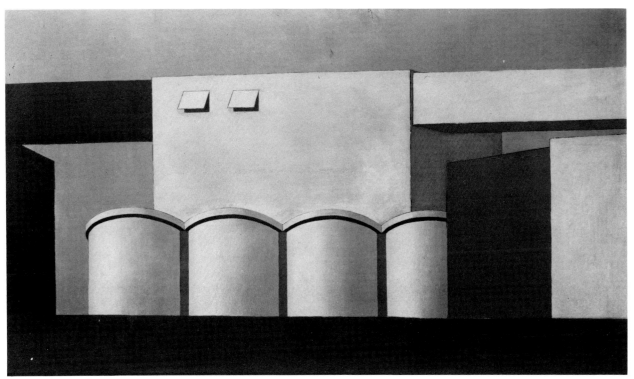

FLOUR MILL #2

Harry Wickey

b. 1892 Stryker, Ohio
d. 1968 Cornwall, New York

Harry Wickey studied at a variety of art schools, including the League, where he attended lectures sporadically from 1916 to 1920 and spent one month in George Bridgman's life class in 1918. During this period Wickey met the artist Maria Rother, whom he later married. She encouraged him to take up etching, and he became known for his boldly drawn landscapes and New York street scenes. From 1929 to 1933 Wickey taught life classes at the League, and in 1930-31 also taught etching. In 1932 and 1933 he was an instructor at the League's summer session at Croton-on-Hudson. During the Depression he started the Harry Wickey Print Club, attempting to sell prints for $5.00 to those who would subscribe in advance, but this venture failed.

By 1935 the close work entailed in etching and the chemicals used in the process had weakened his eyes seriously, and Wickey turned to sculpture.[1] In his autobiography he wrote: "Old Wrestler is one of my first pieces of sculpture, and I look upon it as one of my best."[2] The subject may be George Bothner, lightweight wrestling champion of the world from 1902 to 1912, since Wickey frequented Bothner's gymnasium in New York in the late '20s.

[1] See James Watrous, *A Century of American Printmaking, 1880-1980* (Madison: The University of Wisconsin Press, 1984).
[2] Harry Wickey, *Thus Far: The Growth of An American Artist* (New York: American Artists Group, 1941), 254.

OLD WRESTLER, 1938

bronze, 19" x 8" x 7"
Purchase, 1950

Robert Laurent

b. 1890 Concarneau, France
d. 1970 Cape Neddick, Maine

The important early modernist sculptor Robert Laurent owed his early training, and his exposure to a wide variety of art, to the wealthy American painter Hamilton Easter Field. In 1901 Field brought the young Laurent and his family from France to New York. In 1904 Laurent returned to Europe to continue his studies, sponsored and guided over the next few years by Field. Laurent then joined Field's avant-garde circle in New York in 1910. He first made picture frames for other artists, and then decorative carvings for interior ornamentation. He moved on to make wood reliefs, assimilating aspects of art he admired: African sculpture, Assyrian reliefs, and the work of Gauguin, Matisse and Arthur B. Davies. Laurent was the first artist in this country to revive direct carving, and by 1917 he had begun working in the round. He said of his work: "My approach to sculpture is through the simplification of lines and forms in order to express myself with the knowledge obtained from observation and absorption. I have always preferred cutting directly in materials such as stone, wood, and on irregular shapes in any material. . . . I often start without any preconceived idea."[1]

Laurent taught at the League from 1925 to 1942. He was described in a League catalogue as a "Renaissance artist, where the teacher is not a pedagogue but a co-worker with his pupils."[2] In 1942 Laurent left New York and joined the faculty of Indiana University, where he taught for the next twenty years. *Music* is a study for one of two monumental figures symbolizing music and dance which Laurent made for the lobby of the University's newly-built auditorium. This work depicts "two river nymphs representing vocal and instrumental music."[3]

Music, 1946

cast stone, 15" x 8" x 8"
Purchase, 1950

[1] Peter V. Moak, *The Robert Laurent Memorial Exhibition, 1972-1973* (Durham: The University of New Hampshire, 1972), 18.

[2] *The Art Students League of New York Catalogue for 1933-34*, 40.

[3] Moak, *Robert Laurent*, 30.

José de Creeft

b. 1884 Guadalajara, Spain
d. 1982 New York City

As a sculptor's apprentice in Paris, José de Creeft rejected the usual studio process whereby an artist's clay or plaster model was translated largely by others into a permanent material. He chose instead to work as a commercial stonecutter from 1911 to 1914; this experience confirmed his interest in direct carving and his respect for the material itself. He began carving in wood in 1915, and the following year he completed his first sculpture in stone. Although de Creeft also made innovative assemblage sculpture using found objects in subsequent years, he is best known for his direct carvings. He later wrote: "only materials like wood and stone make possible the permanence and monumentality I have always sought."[1] *Hand of Creation* is consistent with work done throughout his long career in its simplified, abstracted form and organic theme.

In 1929 de Creeft settled in New York City, where his work was enthusiastically received. Later, he became a popular instructor at the League, where he taught from 1944 to '48. Remarkably, he returned to the League in 1959 at the age of seventy-five and taught until the year before his death in 1982. He explained his approach in 1972: "I teach and encourage my students to carve directly because it provides strength through the discipline it requires and the satisfaction it offers in answering the challenge . . . one can find himself in the stone."[2]

THE HAND OF CREATION

white marble, 16" x 12" x 25"
Purchase, 1965

[1] José de Creeft, "Statement on Sculpture," in Jules Campos, *The Sculpture of José de Creeft* (New York: Kennedy Graphics and Da Kapo Press, 1972), 14.
[2] Ibid., 16.

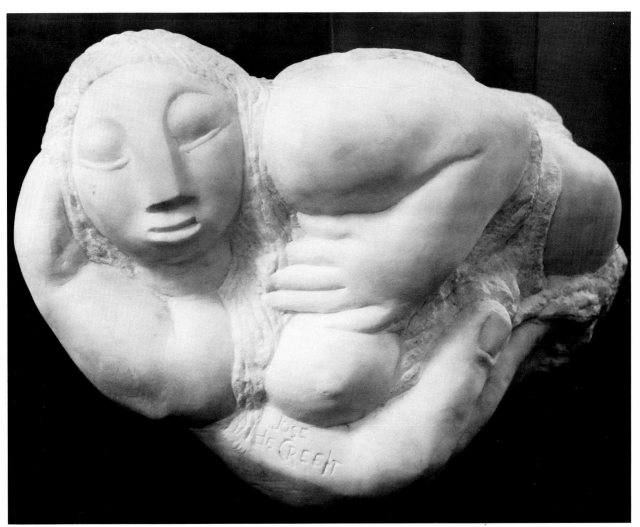

THE HAND OF CREATION

Raphael Soyer

b. 1899 Borisoglebsk, Russia

Raphael Soyer studied at the free schools of the National Academy of Design and Cooper Union between 1918 and 1922, and managed to pay for a few months of classes at the League from 1920 until 1926. Guy Pene du Bois, one of his instructors at the League, was especially supportive of the talented but painfully shy young man. Soyer went through a brief period of primitivism in the late '20s, but soon after adopted the painterly style and contemporary subject matter that would characterize his work for the remainder of his career. Shopgirls on crowded city streets and studies of women in relaxed, intimate poses in subdued interiors were favorite subjects. Soyer's work always reflects the times. In the '30s he painted victims of the Depression, in the '60s, hippies and art students: "The content of my art is people – men, women and children . . . within their daily setting. . . . I choose to be a realist and a humanist in art."[1]

Soyer taught at the League between 1933 and 1942. *Head of a Girl* was given as a gift to Rochelle and Robert Philipp, the latter a lifelong friend and ally in defending realism as a valid means of expression.

[1] Lloyd Goodrich, *Raphael Soyer* (New York: Whitney Museum of American Art, 1967), 21; see also Walter Gutman and Raphael Soyer, *Raphael Soyer: Paintings and Drawings* (New York: Shorewood Publishing Company in association with Rabin & Krueger Gallery of Newark, N.J., 1960).

HEAD OF A GIRL

oil on canvas, 10″ x 8″
Bequest of the Estate of Robert Philipp, 1981

Isabel Bishop

b. 1902 Cincinnati, Ohio

Isabel Bishop took her first League class during the 1919 summer session in Woodstock. She attended regular classes in New York from 1921 until the summer of 1923, working primarily with Kenneth Hayes Miller but also with Max Weber, Frank Vincent DuMond and Robert Henri. She returned to the League in the summer of 1924, and then a year later worked briefly with Allen Tucker, DuMond and Miller. From 1925 until 1931, she was enrolled in the Miller mural class. Although she later complained that this prolonged study with Miller "put me off track for years," on the whole she benefited greatly from Miller's guidance.[1] Bishop, Miller and Reginald Marsh are sometimes grouped, along with several other artists, as the "14th Street School" because of the proximity of their studios in this lower Manhattan neighborhood and the similarity of their subjects and techniques.

Bishop's method of working up to a painting was a long process, starting with drawings. Certain drawings were then re-worked with wash, then an etching and eventually an aquatint was made. Her primary subjects were working girls, people walking in the street, and nudes. Waitresses from the area often served as models. Bishop said: "I try to paint people who appear to be trivial on the outside, and show that they are decent and good on the inside."[2] Bishop taught life classes at the League during the 1936-37 season.

[1] Sheldon Reich, *Isabel Bishop* (Tucson: University of Arizona Museum of Art, 1974), 20.

[2] Ibid., 14.

TWO GIRLS

pencil on paper, 20 ½" x 20"
Purchase, 1985

Edwin Dickinson

b. 1891 Seneca Falls, New York
d. 1978 Wellfleet, Massachusetts

Edwin Dickinson studied at the League with Frank Vincent DuMond and William Merritt Chase in 1911-12. He continued his studies at several other art schools, notably at Charles Hawthorne's school on Cape Cod. Hawthorne's methods paralleled those of Chase, his own mentor, who emphasized painting directly and spontaneously.

Dickinson's mature work falls into two groups. The first is large, figurative paintings with complex compositions and sometimes bizarre elements. The second, which he referred to as his *"premier coups,"* is directly indebted to his Chase/Hawthorne training, and consists of a series of landscapes painted directly out-of-doors in two to five hours. He sought to capture the essence of the scene in a spontaneous manner, and if he was not satisfied, he wiped the painting out. *Gas Tanks* was painted during an especially productive period for these "first strikes," and possibly while Dickinson was living in France.[1]

Dickinson taught at the League in 1922-23 and from 1945 to 1960. After a leave of absence, he returned and taught from 1962 to '66. Summing up his ideas in 1950, he said: "I think it's better to paint from nature. That's the only way to learn to see, which is the crux of the approach to representation. I try to free the eyes of my students from expectations and preconceptions that are not born out in a given appearance. We all have them at first."[2]

Gas Tanks, 1937

oil on canvas, 25¼" x 30½"
Purchase, 1964

[1] See Joe Shannon, *Edwin Dickinson: Selected Landscapes* (Washington, D.C.: Hirshhorn Museum and Sculpture Garden, Smithsonian Institution Press, 1980).
[2] *Art Students League News* 3, no. 4 (February 16, 1950).

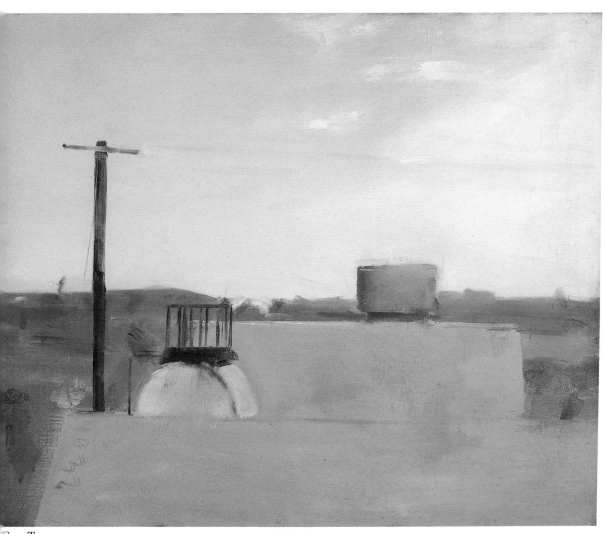

GAS TANKS

Julian Levi

b. 1900 New York City
d. 1982 New York City

At the age of seventeen, Julian Levi enrolled at the Pennsylvania Academy of the Fine Arts, where he studied with Arthur B. Carles and Henry McCarter. In 1919 he won the Cresson traveling scholarship, which he used to visit Italy and France. He spent four years in Paris, where he became friendly with Jules Pascin and well versed in modern trends. He returned to a comparatively unsophisticated artistic environment in Philadelphia, and then in 1932 moved to New York, which provided a more congenial atmosphere.

Levi's paintings were said to be "a product of much brooding and experimentation," and he produced less than a dozen a year.[1] He is best known for his rather melancholy paintings of the seashore, but he also painted portraits and figure studies. In 1942 Levi explained: "As a secondary interest, I cherish the human physiognomy, the painting of people, who for diverse reasons, I find arresting."[2] Levi complained that the climate for commissioned portraiture was not ideal: "Today most of the white-shirted facades are definitely unimpressive to artists."[3] In 1939 Levi painted this informal portrait of Robert M. Coates (1897-1973), a novelist and short story writer who frequently contributed to *The New Yorker* magazine. Coates was also an art critic, and knew many League-associated artists.

Levi taught life classes at the League from 1945 to 1982, except for a leave in 1967-68. A catalogue for the 1959-60 season described Levi as a "coach" rather than a "teacher," "as an artist dealing with fellow-artists of lesser experience."[4]

WRITER AT HOME (PORTRAIT OF ROBERT M. COATES), 1939

oil on canvas, 30" x 25"
Bequest of the Julian Levi Estate, 1982

[1] Ernest W. Watson, *Twenty Painters and How They Work* (New York: Watson-Guptill, 1950), 67.
[2] Monroe Wheeler, ed., *Painters and Sculptors of Modern America* (New York: Thomas Y. Crowell, 1942), 8.
[3] Ibid.
[4] *The Art Students League of New York Catalogue for 1959-60*, 42.

Howard Cook

b. 1901 Springfield, Massachusetts
d. 1980 Santa Fe, New Mexico

Howard Cook came to the League as a scholarship student in his late teens. From 1919 to '22 he studied with George Bridgman and Frank Vincent DuMond, and also took classes in illustration. Between trips to various parts of the world, Cook spent another few months at the League learning etching from Joseph Pennell in 1923 and 1925. He concluded his studies here with printmaker Eugene Fitsch in 1928. By this time Cook had established a reputation for his prints, and had worked as a magazine illustrator for some years. In 1932 he went to Mexico with the aid of a Guggenheim Fellowship and began painting frescoes. During these years Cook and his wife traveled at a dizzying rate, but they eventually settled in New Mexico. Cook's interest in printmaking waned in the mid-1930s as he devoted more time to painting murals. He then began working in watercolor and in pastel, and eventually took up oils.[1]

1 See Ernest Watson, "Howard Cook," *American Artist* 9, no. 3 (March 1945), 8-13; and Betty and Douglas Duffy, *The Graphic Work of Howard Cook: A Catalogue Raisonné* (Bethesda, Maryland: The Bethesda Art Gallery, 1984).

VILLAGE TOWER

oil on canvas on board, 42″ x 13½″
Provenance unknown

79

THE CRUCIFIED HAM

George Grosz

b. 1893 Berlin
d. 1959 Berlin

In 1932 John Sloan, the League's president, suggested that the Board of Control invite the German artist George Grosz to teach a course that summer. After a great debate resulting in Sloan's resignation, the Board finally reconsidered its decision and hired Grosz to teach a summer course. When Grosz arrived in New York he found a large class with high expectations. In the League's catalogue for the following season, Grosz was described as "the most important living satirical draftsman."[1] He was also a serious teacher, demanding that his students adhere to "rigorous draftsmanship and a thorough study of anatomy and perspective."[2] Grosz taught at the League intermittently – during the summers of 1932, 1933, 1949 and 1950, and during the regular sessions in 1933-36, 1940-44, and 1950-59. Explaining why he kept returning, Grosz stated: "I have to teach every now and then. . . . I store up all sorts of painting problems. My class is like a clearing house where we discuss all these problems."[3]

The late 1940s were a difficult period for Grosz, who was saddened by the nightmarish experiences of his German friends and relatives during World War II. Beginning in 1947, he painted a series depicting the "Stickmen," fantastic creatures who attack and torture a fat "man." The stick figures were probably inspired by reports from Germany of starvation and the horrors of the concentration camps. In *The Crucified Ham*, a resolution is reached as the stickmen "crucify" the bizarre, human-like ham.

THE CRUCIFIED HAM, 1950

oil on canvas, 28" x 21"
Purchase, 1950

[1] *The Art Students League of New York Catalogue for 1933-34*, 37.
[2] John I. H. Baur, *George Grosz* (New York: The Whitney Museum of American Art, 1954), 24.
[3] *Art Students League News* 2, no. 11 (July 1, 1949); see also George Grosz, *A Little Yes and a Big No: The Autobiography of George Grosz* (New York: The Dial Press, 1946).

Louis Bouché

b. 1886 New York City
d. 1969 New York City

Louis Bouché got an early start on his art studies as a teenager living in Paris. Upon his return to New York City, he enrolled in George Bridgman's life class at the League in the spring of 1915. During the next year he studied with F. Luis Mora and Frank Vincent DuMond; he later remarked on DuMond's "gentleness and consideration," and praised his "no frills" approach to teaching.[1] Bouché also studied at Woodstock the summer of 1920.

In the late 1920s Bouché ran his own lucrative mural painting business, and continued to paint murals throughout his career. It is hard to say what he had in mind when he combined a manicured, nail-polished hand with a cow's head, but the painting *Cow* probably relates to a 115-foot mural he painted for the lobby of the cosmetic firm of Shulton, Inc., in Clifton, New Jersey in the 1940s.[2]

Strong diagonals and pattern are used to define space in *Murder on the Landing* and other genre pictures Bouché painted from the late 1930s on. The straight-on frontal view with a deep foreground is a compositional device he used often, and these works are frequently peopled with rather diffident characters.

Bouché taught at the League from 1943 to 1965, and was said to be "an exceptionally good teacher."[3] He was known for his warm, witty personality, but was also described as an "instructor who teaches humility."

Cow

oil on canvas, 30" x 30"
Provenance unknown

MURDER ON THE LANDING, 1939

oil on canvas, 48" x 21"
Purchase, 1950

[1] *A Memorial Exhibition of Paintings by Frank Vincent DuMond, N.A. Sponsored by the Art Students League of N.Y. in the Galleries of the National Academy of Design* (New York: The Art Students League of New York, 1952), 4.

[2] Ernest W. Watson, *Twenty Painters and How They Work* (New York: Watson-Guptill, 1950), 15.

[3] Forbes Watson, in *The Metropolitan Museum of Art Presents The 75th Anniversary Exhibition of Paintings and Sculptures by 75 Artists Associated with The Art Students League of New York* (New York: The Art Students League of New York, 1951), 66.

Cow

Reginald Marsh

b. 1898 Paris
d. 1954 Dorset, Vermont

Reginald Marsh took his first course at the League the summer of 1919 while still a student at Yale. Following his graduation in 1920, he entered the League full time, studying mostly with John Sloan and Kenneth Hayes Miller while doing free-lance illustration work. Marsh continued with Miller at the League on and off through November 1923, and also worked briefly with F. A. Bridgman and George Luks. He concluded his studies at the League with another six months in Miller's life class in the late '20s. He later said of Miller: "One of the greatest things that has happened to me is his guidance," and as late as 1944, he commented: "I still show him every picture I make."[1]

Unlike many New York artists who went elsewhere for the summer, Marsh stayed and taught summer classes at the League from 1935 to 1954. He made frequent trips to nearby Coney Island, where he found his favorite subject—hordes of scantily-clad people. He made many studies there, such as *Afternoon, Coney Island*, painted in 1947. "I like to go to Coney Island," Marsh explained, "because of the sea, the open air, and the crowds—crowds of people in all directions, in all positions, without clothing, moving—like the great compositions of Michelangelo and Rubens."[2]

Marsh also taught at the League's regular sessions from 1942 until his death in 1954. Anatomy and drawing were his priorities, and in 1945 his book *Anatomy for Artists* was published to counter what he felt was a decline in these disciplines.

[1] Lloyd Goodrich, *Reginald Marsh* (New York: Whitney Museum of American Art, 1955), 7.
[2] *Art Students League News* 2, no. 1 (January 1, 1949).

AFTERNOON, CONEY ISLAND, 1947

watercolor and gouache on paper, 25¼" x 39⅛"
Purchased from the artist, 1950

fterNOON, CONEY ISLAND

Ossip Zadkine

b. 1890 Smolensk, Russia
d. 1967 Paris

Like many other European artists, the sculptor Ossip Zadkine fled war-torn Europe and came to New York City in 1941. He taught sculpture at the League during the 1944-45 season. It was later reported that he "used to have his League students work for days making copies from the antique, 'so they would know what they were rebelling against.'"[1] Zadkine had developed his own distinctive style of sculpting and drawing using abstracted but figurative forms that share concerns with the work of the cubists (particularly Picasso) and his friend Modigliani. Essentially a romanticist, Zadkine explained: "A sculpture is nothing but an object made of stone, wood or bronze, whose forms and lines contain and always will contain a harmonious mystery and especially an inexplicable power to stir the emotions. . . . Never lose sight of these two languages: the emotive power of the object and your own."[2]

HEAD OF A MAN

pencil on paper, 10⅝" x 8¼"
Gift of the artist

[1] *Art Students League News* 2, no. 4 (March 1, 1949).
[2] Jean Bouret, *Sculpture by Ossip Zadkine, 1890-1967* (New York: Hirschl and Adler Galleries, 1971), unpaged.

Francis Criss

b. 1901 London
d. 1973 New York City

Francis Criss moved with his family to Philadelphia in 1904, and at the age of twelve was enrolled in the Graphic Sketch Club there. He attended the Pennsylvania Academy of the Fine Arts with a scholarship from 1917 until 1919, when he won a Cresson traveling scholarship. Between 1926 and 1931 he studied at the League with Boardman Robinson, Richard Lahey, Kimon Nicolaides, Jan Matulka, and briefly with Eugene Fitsch.[1] Criss was described by fellow student Dorothy Dehner as part of the "core group" in Matulka's class.[2]

As a mature artist Criss painted in a precisionist style, and is best known for his brightly-colored renderings of factories and other structures. One writer described his paintings as "stark decorative abstractions clarified and uncluttered with surplus accessories."[3] This description is especially fitting for his precisionist drawings such as *Building*. Criss also worked as an illustrator, and taught at the Brooklyn Museum, the New School and the School of Visual Arts. He was reported to have taught at the League as well, but this seems unlikely unless he gave a lecture here or acted as a substitute for another instructor.[4]

BUILDING

pencil on paper, 17¹¹/₁₆" x 22⅞"
Bequest of the Estate of Julian Levi, 1982

Letter from Lawrence Campbell to Beverly Rood, June 22, 1987. Campbell explained that Criss sometimes enrolled under his first name, Hyman, and sometimes under his middle name, Francis.

Dorothy Dehner, "Memories of Jan Matulka," in Paterson Sims, et al., *Jan Matulka, 1890-1972* (Washington, D.C.: Smithsonian Institution Press, 1980), 77.

Grace Pagano, *Contemporary American Painting* (New York: Duell, Sloan and Pearce, 1945), unpaged.

"H. Francis Criss," New York *Times*, November 29, 1973, 46, reports that Criss taught at the League, but League records do not support this.

Yasuo Kuniyoshi

b. 1889 Okayama, Japan
d. 1953 New York City

A Board of Control Scholarship enabled Yasuo Kuniyoshi to attend the League, where he studied primarily with Kenneth Hayes Miller from the fall of 1916 to the spring of 1920. By the early 1930s, he had won many awards and was a well-established and completely westernized artist. He returned to the League to teach life classes from 1933 to 1945, again from 1946 to '49, and from 1950 to his death in 1953. He also taught at the League's summer school in Woodstock in 1947, '48, '51 and '52. In 1948 Kuniyoshi likened his teaching at the League to what he valued about America: "It's free and democratic. There has never been any pressure to teach one way or another — never any interference." Kuniyoshi made an effort to treat each student individually, and felt "the human thing is the important thing in teaching."[1] His students and fellow artists remembered him as being an especially accessible teacher who shared his knowledge freely and informally.[2]

In 1916-17 Kuniyoshi made his first group of etchings, which he did not consider worth keeping. He began to make etchings again in 1922 at the Whitney Studio Club, but did not resume in earnest until about five years later. He eventually made over eighty prints, of which *Carnival* is one of the last. The League commissioned this print and others from a group of eight artists. They were sold for $5.00 each during the Christmas season to benefit the League Print Fund. Kuniyoshi made about 235 prints of this image, and gave the League 200 to sell.[3]

CARNIVAL, 1949

lithograph, 17⅞" x 11½"
Commissioned by the Art Students League, 1949

[1] *Art Students League News* 1, no. 7 (November 1, 1948).

[2] See Donald B. Goodall, *Yasuo Kuniyoshi, 1889-1953: A Retrospective Exhibition* (Austin: University of Texas, 1975), with essays by Paul Jenkins and Alexander Brook.

[3] Richard A. Davis, "The Graphic Work of Yasuo Kuniyoshi, 1895-1953," *Journal of the Archives of American Art* 5, no. 3 (July 1965); "League Prints Popular as Xmas Gifts," *Art Students League News* 2, no. 20 (December 16, 1949).

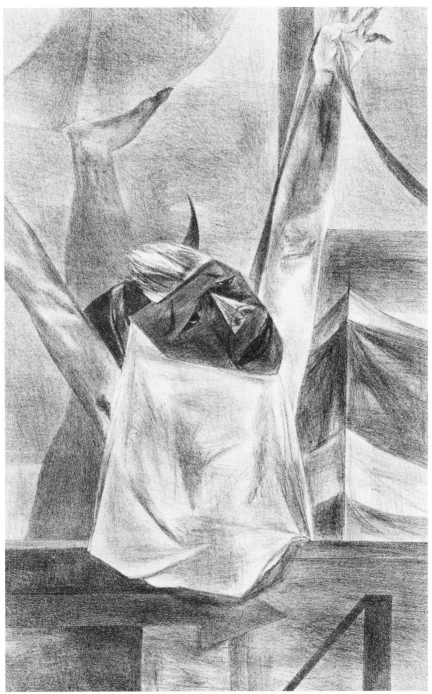

CARNIVAL

Martin Lewis

b. 1881 Victoria, Australia
d. 1962 New York City

Martin Lewis arrived in San Francisco in 1900 and made his way to New York City, where he settled permanently except for a six-year period in the 1930s when he lived in a rural area of Connecticut. In the early years in New York, he supported himself as a commercial artist and painted in an impressionistic manner. He made his first print in 1915, and over the next 30 years made at least 145 prints, favoring drypoint. A trip to Japan in 1920-22 focused his subject matter on scenes from everyday life.

Lewis is most identified with views of New York's bustling street life, dramatized with strong light and shadow, like *Boss of the Block*, made while he lived in Greenwich Village. He enjoyed great success in the late 1920s, but the Depression interrupted his blossoming career. In 1934 Lewis opened the School for Printmakers in New York with his friends Armin Landeck and George Miller, but this venture was short-lived.

Lewis taught printmaking at the League from 1944 to 1952. His superb technical ability made him a demanding teacher. In 1951 he said: "It's hard to make [my students] understand that you can't leave anything to chance. I like them to make a test plate to find out what happens."[1] Lewis's own prints were masterfully crafted with tools of his own making and using a variety of experimental techniques.[2]

[1] *Art Students League News* 4, no. 10 (October 15, 1951).
[2] See Barbara Blackwell, *Emerging From the Shadows: The Art of Martin Lewis, 1881-1962* (Ithaca, N.Y.: Herbert F. Johnson Museum of Art, Cornell University, 1983).

BOSS OF THE BLOCK

etching, 15⅝" x 11⅛"
Commissioned by the Art Students League, 1949;
Purchase, 1987

Robert Philipp

b. 1895 New York City
d. 1981 New York City

Robert Philipp is said to have enrolled at the League in 1909 at the age of fourteen. League records show study from 1911 to 1916 with Frank Vincent DuMond and George Bridgman. Philipp later studied at the National Academy of Design as well. He was a precocious student, and Raphael Soyer remembered that by about 1918, "Philipp was considered one of the bright lights. . . . He was so sure of himself — a tall handsome fellow who was very conscious of his worth."[1] Philipp lived in Paris for about ten years in the '20s. Upon his return to New York, he quickly established a reputation as a portrait and figure painter. His early admiration for Rembrandt can be seen in the earthy palette he often used, while *Farewell to Gloucester* displays his regard for the work of Renoir in its vibrant color and splashy brushwork.

Philipp taught at the League the summer of 1939. He returned to teach in 1948, and remained until his death in late 1981 except for a leave in 1980. He was an emotional man, and as a teacher could be difficult and demanding. He emphasized drawing and color in his classes. "Braque, Rouault and Picasso first were great draftsmen," Philipp stated. "Once they had the technique they could paint any way they wanted to."[2]

[1] Elizabeth Wylie, *Robert Philipp: Artist and Teacher* (New York: Grand Central Art Galleries in association with The Art Students League of New York, 1985), 4.
[2] Ibid., 12.

FAREWELL TO GLOUCESTER

oil on canvas, 45" x 37"
Purchase, 1952

Ralph Mayer

b. 1898 New York City
d. 1979 New York City

Ralph Mayer graduated from Rensselaer Polytechnic Institute in 1917 with a degree in chemical engineering. He went to work in his family's paint factory and several other commercial establishments, where he began to accumulate knowledge about artists' materials. In 1926, at the age of 31, he took his first painting lessons from the artist Bena Frank, who later became his wife. He also attended a watercolor class at the League in November of that year.

Mayer returned to teach at the League, and his classes were the first in the country to focus on artists' materials. In 1930 he lectured on fresco painting. He also taught League-associated artists such as Reginald Marsh and Isabel Bishop how to prepare a gesso panel and paint with tempera. In 1940, he made his extensive knowledge available to all in his book *The Artist's Handbook*, which continues to be a valuable resource. Mayer lectured at the League in 1945, 1957, and 1958, and throughout his life served as a technical consultant to his many artist friends.

Mayer's own paintings are not well known. He painted many New York scenes, and landscapes in this country and in the Caribbean. Mayer worked slowly, often from photographs he made. His painstaking technique and use of simplified, abstracted forms give his work a naive quality.[1]

[1] See Eunice Agar, "The Life and Work of Ralph Mayer," *American Artist* 44, issue 458 (September 1980), 60-64; 104.

UNION ISLAND #1

oil on canvas, 50" x 36"
Gift of Bena Frank Mayer

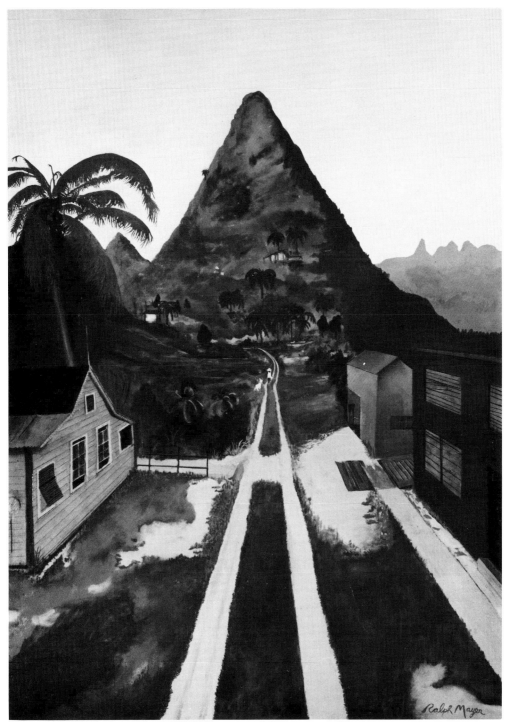

UNION ISLAND #1

John Hovannes

b. 1900 Smyrna, Turkey
d. 1973 New York City

The sculptor John Hovannes studied at the Rhode Island School of Design with Albert Atkins, at the Copley Society of Boston with John Wilson, and at the Beaux-Arts Institute of Design in New York with John Flannagan. Hovannes adopted direct carving in 1928, but used a variety of materials and methods throughout his career and while at the League, where he taught from 1946 to 1973. The League's catalogue for 1959-60 listed Hovannes's equipment as "electric welders, acetylene torches, machine lathes, pneumatic hammers, drills, sanders and other tools," but pointed out that Hovannes believed "that first of all the student must learn to model conventionally and understand tradition."[1] One student, Elizabeth de Cuevas-Carmichael, remembered Hovannes's great personal style and humor, and wrote: "I was amazed at how much he tried to stretch one's thinking, how many aspects of sculpture he brought to conscious attention, from considerations of light and shade, concavity and convexity, rhythm of form — always with concrete illustrations brilliantly devised. . . . he was also a gifted mechanic and a master craftsman."[2]

Dance is a relatively straightforward work compared to some of the complex challenges Hovannes set himself: depicting multiple figures in perspective, clouds of smoke, and bubbles in water.[3] This figure of a dancer incorporates the stylized curves and wonderful silhouette that characterize Hovannes's sculpture.

DANCE, ca. 1950

teak wood, 42" x 4" x 22"
Purchase, 1967

[1] *The Art Students League of New York Catalogue for 1959-60.*

[2] Lawrence Campbell, *The Kennedy Galleries Are Host to the Hundredth Anniversary Exhibition of Paintings and Sculptures by 100 Artists Associated with The Art Students League of New York*, 136.

[3] "John Hovannes, Sculptor, Dies," New York *Times*, April 4, 1973, 37.

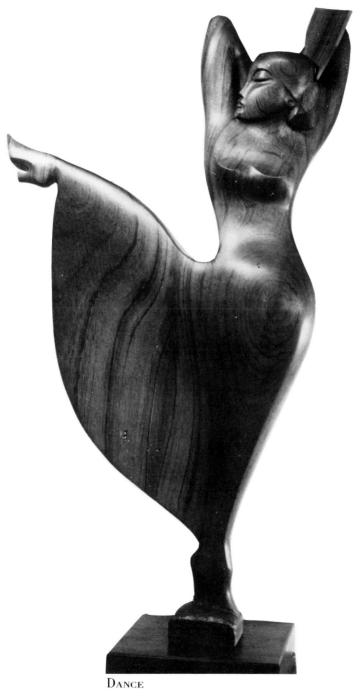

DANCE

Nell Blaine

b. 1922 Richmond, Virginia

At the age of seventeen, Nell Blaine enrolled at the Richmond Professional Institute, where she studied art from 1939 to 1942. "I was intent on becoming an artist long before I knew what it meant," she later recalled. "There was never any doubt about this choice."[1] In 1942 she studied with Worden Day, and later that year came to New York City and worked under Hans Hofmann at his school. She also studied at the League, where she was enrolled in Will Barnet's etching class. Hofmann, however, was the greatest influence during this period. The work of Arp, Mondrian, and later Jean Hélion also served as inspiration.

Her own work was entirely abstract until the late 1940s, then became more figurative during a transitional period from 1949 to '53, as can be seen in *Mountain Towns*, painted during a trip to France and Italy in the early '50s. In 1959 she contracted polio, but after extensive treatment overcame this setback and continued to paint. Over the years her work became more representational, and is marked by vivid color and energetic brushwork. Blaine said of her painting: "I hunt for rhythms in nature, whether it be small or large measures, intimate or grand, but internal rhythm it is primarily."[2]

[1] Edward Bryant, *Nell Blaine* (Hamilton, N.Y.: Colgate University, 1974), unpaged.
[2] Ibid.

MOUNTAIN TOWNS, 1953

oil on canvas, 48" x 29¾"
Purchase, 1966

George Picken

b. 1898 New York City
d. 1971 Tyringham, Massachusetts

George Picken studied with George Bridgman and took classes in illustration at the League from 1919 to 1922. He then took etching and studio classes until the spring of 1923. Picken quickly won recognition for his drawings and etchings. His early drawing of the American Fine Arts Building was used in the League's annual catalogue many times. In 1931 Picken continued his studies in printmaking at the League, concentrating on lithography. Two years later he returned as an instructor, teaching printmaking full-time until 1942 and during the summers of 1939 and 1940.

In the 1930s and '40s Picken achieved a reputation for his paintings of industrial and city scenes. He also painted murals in several post offices in New York State and Ohio. His dark palette and urban subject matter gradually gave way to rural landscapes in brighter colors, painted around his country home in the Berkshires. Picken experimented with abstraction in the 1950s; and in the '60s and '70s he synthesized abstracted form with natural subjects, as can be seen in his work *Fire Island*, painted while visiting his daughter Claire at her summer home.[1]

[1] Information taken from clippings and conversations with the artist's family.

FIRE ISLAND, 1969

oil on canvas, 36" x 24"
Purchase/Gift, 1987

Theodoros Stamos

b. 1922 New York City

Theodoros Stamos began his studies at the American Artists School while a teenager, and also worked with the sculptors Simon Kennedy and Joseph Konzal. As a young man Stamos became friendly with many abstract painters in New York, and he is generally considered to be part of the "first generation" of abstract expressionists.[1] While his paintings are non-figurative, they are always derived from nature, often relating to mystical forces of growth and beginnings. "*Soundings #2* was created after hearing the sounds of sea turtles in front of my house in Greece, in the sands, starting to break through their shells and head towards the Ionian Sea," Stamos recently explained. "I listened, looked and saw the whole phenomena. *Soundings #2* is the 'result' of such sounds."[2]

Stamos taught at the League from 1958 until 1984, except for leaves in 1974-75 and 1980-81.

[1] Barbara Cavaliere, *Theodoros Stamos: Paintings 1958-1960* (New York: Louis K. Meisel Gallery, 1981).
[2] Theodoros Stamos, letter to Ronald Pisano, April 2, 1987.

SOUNDINGS #2, 1962

oil on canvas, 18½" x 48"
Purchase, 1968

98

Soundings #2

Fairfield Porter

b. 1907 Winnetka, Illinois
d. 1975 Southampton, New York

Fairfield Porter graduated from Harvard with a degree in fine art in 1928. He entered the League in October of that year, and took life classes with Thomas Hart Benton and Boardman Robinson until the spring of 1930. In a 1968 interview, Porter remembered that he preferred Robinson's class, saying, "He taught *you*, he didn't teach a system."[1] A city scene painted in Benton's class was reproduced in the League's 1930-31 catalogue, and shows a distorted, expressive style completely unlike Porter's later work.

Porter's more mature works show his love for the quality of paint itself and his use of pale, fresh color. His subjects were usually set in and around his homes on Great Spruce Head Island in Maine and in Southampton, New York, and often incorporate members of his family. *Katie*, a portrait of his fifteen-year-old daughter, shows the result of Porter's deliberate and intellectualized effort to "get the concept of reality down" in a seemingly ordinary, natural way.[2] Porter was an associate editor for *Art News* in the 1950s, and until recently was better known for his art criticism than for his own paintings.

[1] "Conversation with Fairfield Porter, conducted by Paul Cummings," in John Ashbery and Kenworth Moffett, *Fairfield Porter (1907-1975): Realist Painter in an Age of Abstraction* (Boston: Museum of Fine Arts, 1982), 51-52.
[2] Ibid., 56.

KATIE, 1964

oil on canvas, 15" x 14½"
Anonymous gift

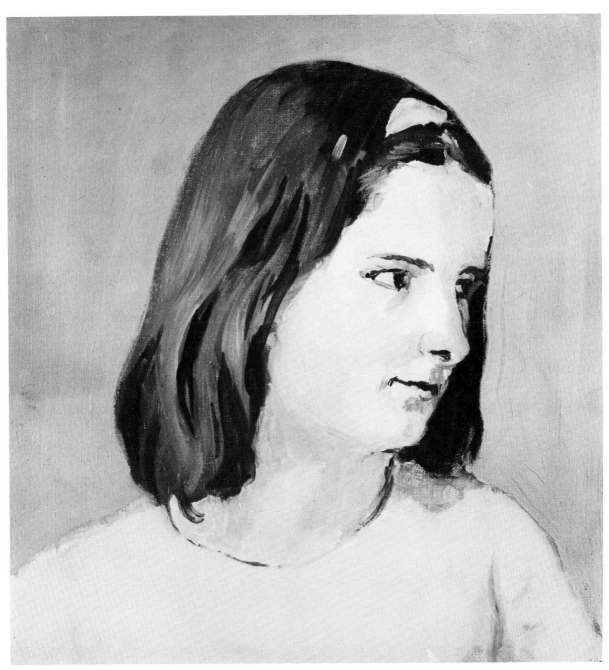

KATIE

Stephen Greene

b. 1918 New York City

After a year of study at the National Academy of
Design, Stephen Greene attended the League between
1937 and 1942, where he studied primarily with Morris
Kantor. He also worked briefly under Alexander
Abels, William Zorach, Yasuo Kuniyoshi, Reginald
Marsh and George Picken. In the late 1940s and early
'50s, he developed a symbolist, expressionistic style
reflecting themes of alienation and sadness. His
paintings became increasingly controlled and abstract
over the years, dealing with more formal concerns.
Greene taught at the League from 1959 to 1966; about
the time that he left, he began making paintings and
drawings with large areas of open space contained
by finely drawn lines and enlivened with areas of
bright color, as in *Plan 1967*. In these works a careful
tension is maintained between geometric and organic
forms.[1]

[1] See Dore Ashton, *Stephen Greene: A Decade of Painting*
(Akron, Ohio: Akron Art Institute, 1978), and Barbara Rose,
Stephen Greene: Twenty-Five Years of Drawing (New York:
William Zieler, 1972).

PLAN 1967

oil on canvas, 32″ x 36″
Purchase, 1967

PLAN

A Collection in the Making

In examining the history of the Art Students League's collection, it is clear that the founders of the organization deemed it mandatory that they should form a collection of art from which students could study and derive inspiration. It was painfully apparent to them that little fine art was accessible to art students in America. As one student in the school explained: "At that time we had almost nothing to look at in New York. A few pictures in the Lenox Library, a few at the Historical Society (provided one could get cards from a member) some in the Metropolitan Museum, then occupying a small building on West 14th Street. There was an occasional, good modern picture at one of the two or three dealers, when we all flocked to see and study."[1] Realizing the gravity of this situation, the founders of the League included in their original mandate of directives (July 1875) as one of its primary objectives: "the accumulation of works and books of art."

The League considered it crucial for students to be exposed not only to fine art—original when possible, copies and reproductions when not—but also, given the League's progressive policies, to the most modern developments in art as well. This was accomplished by organizing temporary exhibitions of the most advanced work available of both American and European artists. One such show took place in January 1879. Contrasting the daring works of art on display with the more sentimental and anecdotal art that was favored at the time, one critic warned the public that this exhibition offered "no popular element . . . to award those who are not devoted to art in the highest and most advanced stage."[2] Included were works by William Blake, Mariano Fortuny, John LaFarge and James McNeill Whistler; also on view was a group of paintings by Venetian artists, probably contemporary, lent by William Merritt Chase.

Whatever, if anything at all, was in the League's "permanent collection" at this time certainly could not have compared favorably to the holdings of the National Academy of Design. The National Academy, from the time of its founding in 1825, required all candidates for membership on an associate level to present to the collection a self-portrait, or a portrait of the candidate by a fellow artist. Election to full membership obligated the artist-elect to donate a representative example of his own work. Thus, the Academy amassed an extensive collection of works of art by all its members. The parameters of the Academy's collecting have provided it with an extremely important and comprehensive overview of the work of artists associated with the institution, supplemented by the works of some who were not.[3] However, its impressive holdings do, to a degree, lack the spontaneity and variety and a bit of the "personality" of the League's collection. This is especially true of the works of art included from the twentieth century.

The Art Students League never required its members (students or teachers) to donate their work to its collection. While realizing the importance of having a collection, especially during the early years, the League took no formal measures to form one. This can be attributed to several factors: the founders of the League were determined to establish an informal association, with a more liberal and inclusive membership policy than that of the National Academy; there were insufficient funds to form a meaningful collection through purchasing works of art; and until 1892 (when the League moved into its present location) there was inadequate space in which to display or even store such a collection. In spite of these negative factors, a collection was formed. Unfortunately, no early documentation of this collection has been found; thus in some instances it is not clear how or when some of the artwork was acquired.

The first serious attempt to establish a collection can be traced back to 1882; by that time not only was the League financially stable, but there was a surplus of funds. Its President, William St. John Harper, who had recommended that a "reserve fund" be set up, also suggested that part of the interest from this fund be used to add to the permanent collection of the League, stating: "There is no reason if the members will take the matter earnestly in hand why our painting room should not be one of the most attractive studios in the city, and of itself an education in color." Other provisions for establishing a collection were made as well: Harper announced that a project had been initiated to form a collection of drawings by distinguished foreign artists (once again underscoring the international emphasis of the League's philosophy as opposed to the more insular position of the National Academy). Furthermore, a new by-law was passed, which relieved all members of the League who were studying abroad of any membership dues, allowing them to retain their membership free of charge. In lieu of this waived fee, it was requested (not demanded) that such members send back works of art by themselves and other art students for the League's permanent collection. Just what entered the collection by this means is impossible to determine; however, Frederick Freer, who began teaching at the League two years later, may have been inspired by such a request to donate his early study, *Portrait of a Man*, to the collection.

The first suggestion of any possible collection owned by the League is a reference to the school's quarters in the Sohmer Building, where they began renting space in 1887. The source refers to the setting as being up one flight of stairs with "several partition doors at the head of the stairs. One led to the office and information bureau, another to the library and reception room where large portraits by Hals, Moroni, Rembrandt and others indicated the art atmosphere." The same writer described the life classes on the top floor: "They were open rooms, without screening, decorated with photographs and studies by the prize men and by well known artists." It is clear from these accounts that despite the lack of a formal gallery, the artwork displayed provided an artistic atmosphere.[1]

It is doubtful that any major attempt was made to form a serious or comprehensive collection reflecting the League's heritage until it moved to its permanent location on Fifty-seventh Street in 1892; and in fact, the great majority of the collection was acquired in the twentieth century, with the number of additions increasing over the years. At times, these works of art were purchased not only to augment the collection, but also to assist artists or aid members in times of particular need. As mentioned earlier, the League's 1875 charter specifically offered "sympathy and practical assistance (if need be) in times of sickness and trouble." Such an instance led to the acquisition of Nell Blaine's *Mountain Towns*, as she explains: "—a special committee approached the League which purchased this and two other works to aid me in a trip to England, Europe and the West Indies. The purpose of this painting trip was unusual: to keep my special English, polio-trained nurse, who was also a painter, with me. She was a therapist and assistant with qualifications difficult to replace. A bill introduced in Congress and passed in the House, had stayed her deportation to England only temporarily (she had been a former Fulbright exchange nurse at Mt. Sinai, New York, where I was flown from Greece in an iron lung in 1959). . . . This and other similar purchases allowed me to travel and paint in Dorset, England, plus spend eleven months in tropical St. Lucia, which I would undoubtedly be unable to do otherwise."[5]

Other works were donated by the artists. This is apparently how William Merritt Chase's painting *Fish Still Life* (a demonstration piece painted for the benefit of his class at the school), was acquired; and more recently, Dorothy Dehner's early painting *Portrait of Weber Furlong (Wilhelmina Weber Furlong)*. Other paintings entered the collection as purchase prizes awarded to students, which accounts for an important early example by Georgia O'Keeffe, *Dead Rabbit and Copper Pot*, as well as Eugene Speicher's *Portrait of Georgia O'Keeffe*.

Still other artists who obviously felt a strong personal attachment to the League expressed their gratitude by leaving the school their paintings to be sold for its benefit. A trust was created with the large number of paintings by Allen Tucker left at his death, which was later turned over to the League. Julian Levi and Robert Philipp left the League not only their own paintings but works of art by their colleagues. Included in the Levi bequest were many important works on paper, such as Louis Lozowick's lithograph *Breakfast* and Francis Criss's drawing *Building*. Among the works of art received in the Philipp bequest was Raphael Soyer's painting *Head of a Girl*. Gifts from artists' descendants are an important part of the collection as well: William Zorach's *Bronze Torso*, donated by the artist's son Tessim, is an example. More recently, donations have been made by wives of artists who had been associated with the League, such as Bena Frank Mayer's gift of Ralph Mayer's *Union Island #1*. Although the collection focuses first and foremost on artists associated with the Art Students League, works of art by other important American artists have been accepted gladly; Ralston Crawford's *Flour Mill #2* was a particularly welcome example in this category. The painting was donated by Muriel Hillman, a former member of the League, who served on its Board of Control.

This dynamic and impressive collection is of special interest historically, but it is by no means a compendium of all the artists who have studied or taught at the League. The original intent of the founders in 1875 was to form a collection that would prove useful as a study collection for its students. Obviously that is no longer necessary given the fine museums in New York City. Therefore, the purpose of the collection has shifted somewhat, reflecting the rich heritage of the League and inspiring its members to become a part of that tradition. It has become a major goal to continue to improve and expand this collection in order to include the work of as many of the important artists who were associated with the League as possible. Among the nineteenth-century artists who are still unrepresented are Thomas Eakins, Childe Hassam, John H. Twachtman, Thomas Dewing and J. Alden Weir. Early twentieth-century artists still missing include George Bellows, Stuart Davis, William Glackens, Everett Shinn and Max Weber; and more recent artists still unrepresented in the collection are James Brooks, James Rosenquist and Roy Lichtenstein. Sculptors from the nineteenth and twentieth centuries who are not represented include Daniel Chester French, Frederic Remington, Augustus St. Gaudens, Paul Manship, Louise Bourgeois, Alexander Calder and David Smith. Clearly it would be impossible for the League to ever compile a collection representing every important artist associated with it—such an accomplishment would be prohibitively expensive if the League had to rely on purchase funds to acquire all of these works. However, given the loyalty of League members and their indebtedness and fond memories for this organization, important donations of impressive examples of artwork continue to be made.

As the direct use of the League's collection for study purposes diminished in the twentieth century, it took on a very different meaning for the institution and its students. It has become a very personal collection, celebrating the achievements of former students and instructors who contributed to the continuing success of an independent art school. The collection now serves not only as an instructional tool and an inspiration to its students, but also as a source of pride for all members of the League. There is a definite continuum in the collection, an artistic lifeline: from former students who became instructors themselves to their students and their students' students. And yet, given the diversity of the artistic and educational approaches allowed, even encouraged under the school's founding premise, there is no sense of inbreeding—just a strong emotional and artistic bond. Indeed, there is something that cannot be explained, only experienced by those who pass through the doors of the Art Students League, take part in its activities and are touched by the loyalty and pride of those who have made and continue to keep it a vital institution. This personal association and dedication ensure that the League will build an even broader and better collection, one that will continue to be, like its own building, a landmark in American art.

[1] *Hundredth Anniversary Exhibition of Paintings and Sculptures*, p. 20.

[2] "The Art Students League," New York *Times*, January 8, 1879, p. 5.

[3] For information regarding the National Academy of Design, see Lois Marie Fink and Joshua C. Taylor, *Academy: The Academic Tradition in American Art* (Washington, D.C.: National Collection of Fine Arts, Smithsonian Institution Press, 1975).

[1] The old master paintings described as being in the library and reception room were undoubtedly copies made by League instructors who had studied abroad; and the studies by "prize men" were most likely works by students who had been awarded scholarships or other such prizes. Finally, the works mentioned as being by "well known Artists" were probably paintings by League instructors and their colleagues that they lent or donated to the school for display.

[5] Nell Blaine, letter to Ronald Pisano, April 7, 1987.

Afterword

Dr. Van Dyke of Harper's magazine stated many years ago that "the aim of the Art Students League is not to make poets in paint, nor to transform stupidity into genius, but to make thorough craftsmen, good workmen, people who, when they thrust a thumb through a palette know what to do with the other hand. The League is creating an artistic sense and laying the foundation in technical knowledge upon which American artists may rear a palace of art."

The collecting of works of art of League artists began in earnest in 1950. The League's 75th Anniversary exhibition was hosted by the Metropolitan Museum, and another was held at the National Academy. The League purchased many art works, and some of them are represented in the exhibition. I have personally begun a more extensive program. We have been fortunate in inheriting many collections—Reginald Marsh, Robert Philipp, Julian Levi, Allen Tucker and many others.

The League's history is outstanding. It has grown from a small group of artists in 1875 to a school with a registration of 2500 students. The years in between were important and vital to the growth of American art. (For additional history about the League, we are indebted to the League's historian, Lawrence Campbell. Plans to publish his research in a book are underway.) Always considered a school of the avant garde, it continues as it began—a professional art school. All forms of art are taught, from traditionalism to the non-objective. Tuition is still charged by the month.

I would like to quote Henry McBride who, in 1950, stated in *Art News:* "The special marvel about the Art Students League is the way it persists. Like Tennyson's 'Brook' it is the one thing constant in a shifty world. In a shifty city, I should say. In the most evanescent of all known towns, in the most here today and gone tomorrow of all cities, it maintains the same establishment on West 57th Street, New York that it had when I first knew it, some time in the '90s and I think maintains it rather better now than then. All else around it and about it has changed, altered as though by a swish of a magician's wand, but there it still stands, the Art Students League."

Finally, the Board of Control and I want to thank Christopher Crosman, Director of the Heckscher Museum, the Gallery Association, Beverly Rood, and Ron Pisano, whose idea it was to have this exhibition.

Rosina A. Florio
Director
The Art Students League of New York

For the non-artist—even those of us supposedly famil-
iar with the processes and materials of art and with art
school environments—the Art Students League is an
entirely new and surprising experience. There is a
sense of informal, casual ease coupled with tremen-
dous energy; the sometimes chaotic administration
office (where part of the Art Students League Collec-
tion is hung floor to ceiling) and the intense concen-
tration one finds among students in the studios.
Young and old, Bendel dresses and the barely
dressed mingle in hallways. The building itself has
the look of a slightly rumpled student who forgot to re-
move his dinner jacket before class. It is unquestion-
ably a place where art is the only thing that really
matters. In New York it is wondrously reassuring to
know that the League is there, especially on a street
where some of the most prestigious commercial gal-
leries in the world would have us believe art can only
exist in carpeted, glass and chrome showrooms. If you
want to understand how art lives and breathes and
makes rude gestures and pulses with excitement, then
visit the Art Students League. The League's special
character is in large measure a reflection of its re-
markable Director, Rosina Florio. New York is full of
institutions, but only a few are so alive and so well.

Christopher B. Crosman

Director
Heckscher Museum

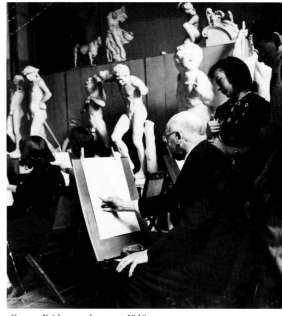

George Bridgman class, ca. 1940